# BE
# MORE
# SAUSAGE

HarperCollins*Publishers*
1 London Bridge Street
London SE1 9GF

www.harpercollins.co.uk

First published by HarperCollins*Publishers* 2020

10 9 8 7 6 5 4 3 2

Photographs: p3, 6, 9, 13, 17, 18, 21, 27 29, 35, 37, 41, 45, 47, 48, 55, 59, 64, 71, 72, 75, 80, 83, 92, 96, 101, 110, 113, 115, 119, 123, 127 © Shutterstock.com; p23 Marcus Wallis on Unsplash; p60 Eduardo Casajus Gorostiaga on Unsplash; p128 courtesy of the author.

A catalogue record of this book is available from the British Library

ISBN 978-0-00-840564-9

Printed and bound in Canada

For more information visit: www.harpercollins.co.uk/green

# BE
# MORE
# SAUSAGE

### Lifelong lessons from
### a small but mighty dog

## Matt Whyman

# CONTENTS

# HOW I LEARNED TO GET OVER MYSELF AND LOVE THE SAUSAGE DOG

We had a deal when it came to the dachshund. According to the family agreement, the new dog belonged to my wife and children. He would be their responsibility, and not mine.

'I already have a dog,' I reminded my wife, as if anyone could overlook the large snow wolf that sat obediently at my side. 'A proper one.'

## THE ALPHA DOG

Technically speaking, Sesi wasn't a wolf. She just looked like one.

A white shepherd, Sesi sported upright ears and a lean, solid torso, with muscular haunches and a low-set tail curved like a sabre. I'd never been a fan of big, scary dogs until a few years back when we moved from the inner city to the countryside. There, on the edge of woodland, I found myself terrified of two things: the darkness and the silence. Sesi was the solution. She allowed us to sleep safely in our beds at night. Even so, it took me a while to feel comfortable in public with a dog of this calibre. The canine equivalent of a monster truck, she was so strong that walking her became an exercise in restraint. People would take one look at the slathering hell hound straining at the leash and cross to the other side of the lane.

After a while, I stopped apologising and trying to explain that she was a softie inside, and just rolled with it. When I walked Sesi through a tranquil village largely populated by old-timers, nobody messed with me.

## THE NEW ARRIVAL

So, when my wife, Emma, announced that she had fallen for a sausage dog – and not just any sort, but a *miniature* variety – I laid down my terms and conditions. I had no doubt that the children would adore a new puppy, but someone would have to clear up the mess, and that someone wasn't me.

'We'll do everything,' she promised, and then lowered her voice a little. 'Where possible.'

With great fanfare, the puppy arrived on a Friday afternoon. I barely saw the new addition to our household, such was the care my wife lavished on him amid the scrum of our children. That suited me just fine. I holed up in my home office and let them get on with it. In fact, I only got involved when it came to the naming process:

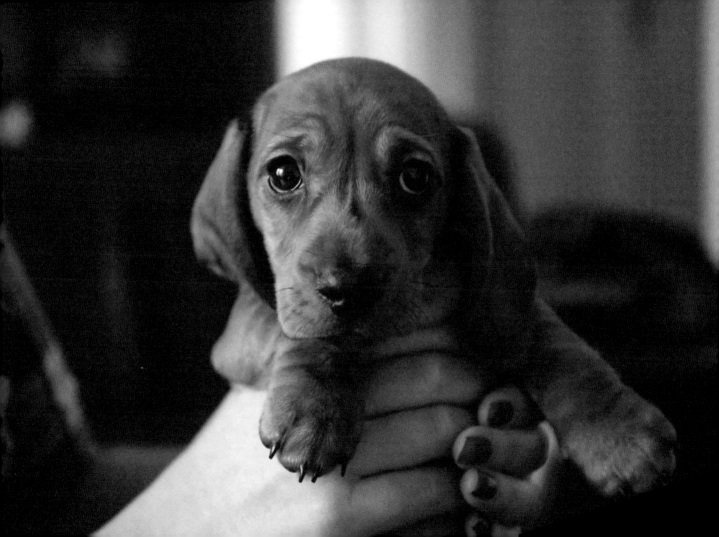

'You can't call him Bieber,' I said. 'Be reasonable.'
'Bublé?'

Emma was cuddling the puppy over her shoulder.

It looked like she had taken to wearing a draught excluder as an accessory. The dog turned to peer at me. I wanted to suggest Slinky but just couldn't bring myself to do it.

'He needs a name that inspires respect, not ridicule,' I said. 'How about Duke?'

'Dad!' I have four children. In unison, they didn't have to say much to express their opinion.

'Horatio?'

'Stop being so stuffy.' My wife was now cradling the puppy's head as if to shield him from this conversation. 'Harry Styles?'

'*Hercules!*' I shared the name as soon as it sprang into my mind, and then watched the kids try it out as if chewing on coffee Revels. It was perfect, I decided. 'He's going to need an epic name to survive life with Sesi.'

'If we call him Hercules,' said Emma, who then waited until she had my full attention, 'does this mean you won't tut every time we say his name?'

'Promise.' I pressed one hand to my chest. Then, against my better nature, I tickled the puppy with one fingertip. 'I can live with Hercules.'

With the sausage dog in our midst, the weekend sailed by. At least, it did for me. My wife and children were so besotted with the new arrival that I barely saw them. Then came Monday, and with it the start of the school and working week.

'Have a good day,' Emma said on the way out to do the school run before she headed for the office. 'I'll be in meetings mostly, but you can always text.'

'What about Hercules?'

The pup was busy clambering over my slippers. I scooped him up and held him out like she'd forgotten her lunchbox.

'Feed him at around midday and when the kids come back from school,' she said, as if that was all there was to it, then kissed us both. 'You're so lucky, working from home!'

It wasn't the first time I had found myself providing day care for pets awaiting the return of their owners. We'd had our fair share of goldfish, gerbils and rabbits. Once, Emma had even gone so far as to adopt a pair of not-so-mini pigs. Butch and Roxi – names that had been overruled by her as my suggestions for children – had arrived in a cat basket. Several years later, having grown to weigh in at twenty-five stone each, they left in a horsebox for life turning the fields on an organic sheep farm. Our back garden had yet to recover from that ordeal, and to an extent nor had I. As much as Emma assured me that I'd barely notice the addition of a little sausage dog during working hours, this one was peering up at me as if awaiting a rundown of the entertainment options on offer. I sighed to myself and hoped that Hercules would quickly find his feet.

## ON GUARD

As it turned out, it was Sesi who stepped up to help me out. After her initial disbelief that this elongated scrap could even be classified as the same species as her, she took him under her wing. She became very close to Hercules, in fact, in the same way that a lioness might adopt an orphan monkey. I did wonder whether having such a formidable maternal figure instilled more confidence in the little dachshund than he might've developed on his own terms. After just a short while in my care, Hercules took to stationing himself on top of the office sofa overlooking the front path. Then, when the post arrived, he would kick off as if we were about to receive a suspicious package.

'Stand down,' I said, scooping him from his sentry post. 'Our security threat level is not at critical.'

## SAUSAGE LIFE

As the weeks ticked by and Hercules found his place in the family, I found he looked less ridiculous in my eyes. I became used to his long body and funny little waddle when he scuttled across the house to greet my wife and children at the end of each day. They adored him, and that made it hard for me to retain the moral high ground regarding his daily upkeep.

It wasn't difficult to look after a dachshund, I discovered, just as Emma had promised. They are far from stupid dogs, and despite being low to the ground, Hercules still seemed to consider himself to be on a level with me. While Sesi preferred to bask in the yard, he'd sit on the sofa as I worked, as if his presence was responsible for my productivity. It was quite endearing. I even found myself talking to him at times.

In the comfort of my own home, I started to notice his personality more than his physical shortcomings. I suppose I became steadily desensitised to his unique body shape. Until, that is, Hercules was old enough to head outside for walks. Given the fact that they were at opposite ends of the canine spectrum, there was no way that I could exercise him with Sesi at the same time. So, having been dragged around the village by what looked like an apex predator, causing locals to scatter from my path, I returned home and switched dogs.

## THE WALKING CHALLENGE

The experience was a little bit like jumping from the driving seat of one car and into another. Everything is essentially the same and yet feels completely different. Leaving the house with Hercules, I sensed no pull on the lead at all. Instead, I discovered, I had to shorten and then quicken my footsteps to avoid tripping over him. He was just so long that even if he trotted ahead, his hindquarters remained within kicking distance. What's more, being so low to the ground, the little dachshund picked up on scents that other dogs might miss. As a

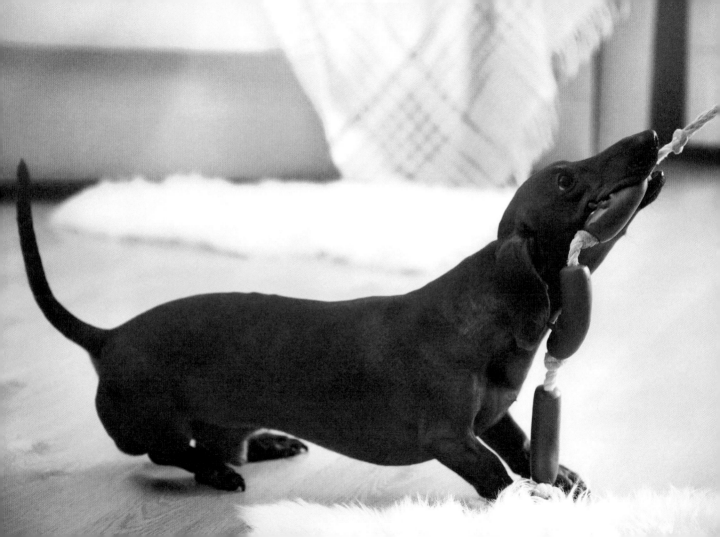

result, he would stop dead without warning, which left me with no option other than to break into a little skip to avoid stepping on him.

Sesi weighed close to forty pounds. She could've eaten Hercules for breakfast and still been hungry. With such a featherweight little dog in my care, I had no need to brace my arm across my chest to counter the strain or bind the end of the leash around my fist. Instead, in a bid to maximise the distance between Hercules's rear end and me, I extended my arm in front of me and just lightly pinched the lead between thumb and forefinger.

I had it all sorted by the time I registered a cyclist riding towards us. All of sudden, I became incredibly self-conscious. Having lived in a bubble with Hercules since his arrival, I now realised that I wasn't so much walking a dog as sashaying in his wake. Outside in public with a miniature sausage dog, after years of manhandling a massive white shepherd, I felt completely ridiculous. On seeing the cyclist acknowledge me with a grin,

I dropped my gaze to my feet and cringed so hard it hurt.

On the circuit, which I eventually cut short, we passed several locals. With Sesi in tow, they'd have given me a wide berth. Now, even if they didn't all chuckle outright, I found myself giving just one explanation as to what was going on here.

'This is Hercules,' I told them all as we breezed by. 'My wife's dog.'

For a short while after that first outing, Hercules might well have assumed that all human life beyond our family had ceased to exist. This was down to the fact that I could only bring myself to walk him after dark along isolated footpaths.

'You're being ridiculous,' Emma said one day, and our children backed her up. 'You can't keep avoiding people.'

'I just feel so stupid,' I reasoned. 'What does a dog like this say about me?'

'Where shall I begin?' she asked, but there was no

need for her to do that.

The fact was, I liked Hercules. In the short time he'd been with us, he'd moved into the heart of my family. He was loud, proud and incredibly loyal, while there was nothing he liked better than a walk. Unless there was dew on the ground, which he didn't enjoy as it meant his undercarriage got wet quickly. Trotting up front on a dry day, however, with his head held high like a cross between an aristocrat and an otter, this was a dog who had no idea how much I was dying on the inside behind him.

It was, if we go to the heart of the issue, my problem and not his.

## RISING ABOVE IT ALL

The next time we ventured out under moonlight, I found myself having a long, hard think. For here was a dog with no concern for his appearance or apparent shortcomings. If I chose to be more concerned about what other people might think of us, then more fool me.

Unless I changed my world view, I realised, only one of us would continue to make the most of the cold night air and moon-silvered solitude that the British countryside has to offer.

The next day, having taken Sesi for her morning prowl, I followed my footsteps with Hercules. This time, I set out to share his attitude. I refused to look at my feet, greeted everyone cheerily and focused on the world around me rather than my insecurities. If people had a problem, I kept telling myself, that was their lookout and not mine. With every walk we enjoyed in this manner, I felt more like the person I wanted to be. Like Hercules, I found an inner confidence that rose above ridicule or a fear of being judged. I was happy. Relaxed. Comfortable in my own skin.

And it was a liberation.

## THE LONG GAME

Hercules is ten now. He's getting on. While Sesi sadly passed away some years ago, a generation ahead of her unlikely little friend, Hercules has gone on to become an elder statesman of the sausage-dog world.

Since I wrote a memoir about my experience in coming to terms with life as an owner of a miniature dachshund, he's also become a familiar face. Hercules is often invited to open fetes, attend talks and, of course, sausage-dog walks, in which hundreds of dachshund owners and their dogs assemble for a grand promenade.

I've come to understand what makes Hercules tick, as well as countless numbers of his kind, and learned from experience that there's a great deal they can teach us. The dachshund might be seen as the embodiment of the disadvantaged dog, and yet it lives life to the fullest like no other. What's more, in recent years it's grown from a canine curiosity to become *the* hot dog in countries across the world. Yes, it looks like no other breed, but there must be more to our bond with the dachshund than that.

So, rather than consider it as no more than a canine comedy act, let's celebrate the sausage dog in all its glory. What drives the dachshund to forge its mark on this world so magnificently? How does it make each and every day count, successfully manage everything from relationships to conflict, play life to its advantage and maintain and inspire so much love?

If we can just look beyond appearances, we'll find that they're a lot like us in many ways, which leaves us with just one question: what can the sausage dog teach us about being human?

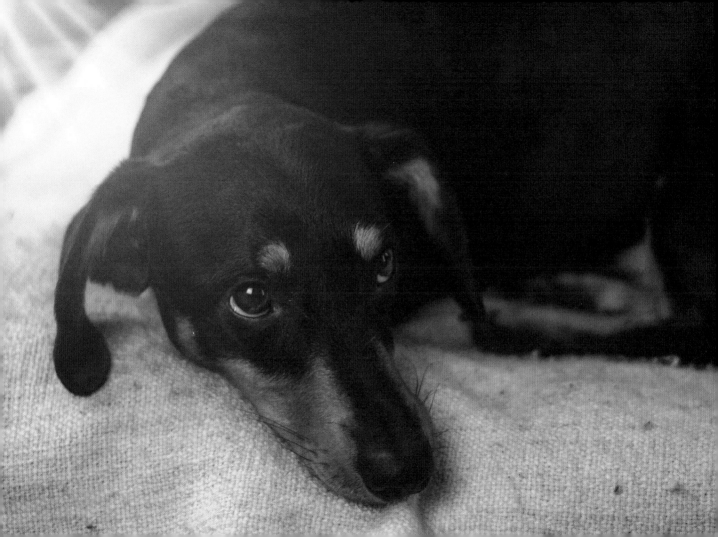

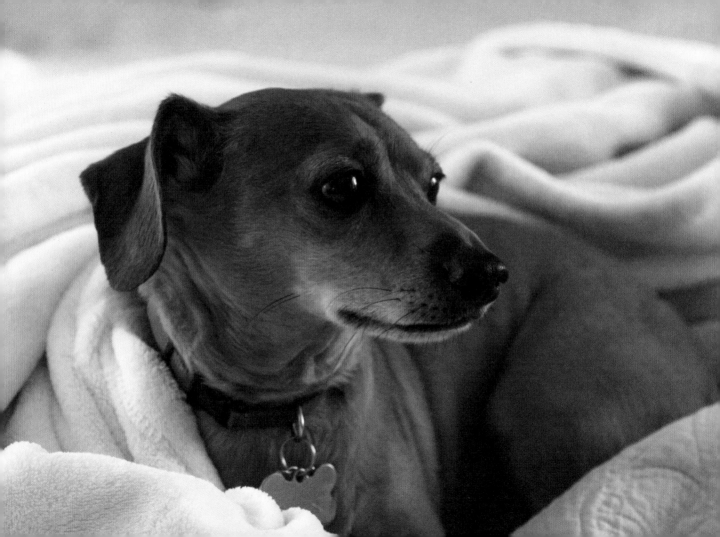

# 1. DACHSHUND THROUGH THE DAY

When life is short, we grasp every moment available to us. Time becomes precious, and with that comes a sense of purpose. We become focused on extracting the maximum from everything we do, which means savouring each second.

We're not just talking about the sense of urgency that comes from limitations to our longevity here. Standing at five to seven inches at the shoulder, which is next-level short, the sausage dog views each day like a postal worker's ankle: something to be seized with passion and zeal.

Despite a world view that's blocked by almost everything in his path, the sausage dog sees only opportunity. He can't hope to perch his front paws on the kitchen counter to swipe that slice of cake you've just cut for yourself. Instead, he'll deploy an alternative method of claiming his prize, and will do so with ruthless efficiency. Any dachshund owner who has ever sat down to enjoy a cup of tea and a slice of Battenberg will be familiar with 'the look' delivered to them from floor level. Sure, you can resist, but the sausage dog's wounded expression will only deepen. As will your sense of guilt and selfishness until only one option is available to you.

Of course, most dogs know how to hold out for a treat. Only the dachshund sets out to make you feel really bad for not bending to his will. It's not just in his eyes. It's his whole demeanour. When it comes to body language, nothing demands pity more forcefully than an elongated pooch with paddles for feet.

'Look at me!' he pleads silently, and no matter how strong-willed you're feeling, that cake is bound for the hound. 'I'm the most disadvantaged dog in existence, and you won't even share a crumb!'

Without question, when it comes to seizing the day, the sausage dog lets nothing go to waste. From the moment he wakes to curling up at night in a spiral and then back around to daybreak, the dachshund is devoted to maximising life at work, rest and play. Here's how Hercules and his kind ensure that the winning never stops …

'Despite a world view that's blocked by almost everything in his path, the sausage dog sees only opportunity.'

## AT WORK

Despite looking like his only useful purpose in life would be to serve as some kind of lumbar support cushion, the dachshund is in fact classed as a working hound. Believed to have originated in Germany in the eighteenth century, the early sausage dog was in fact known as a *'Dachs Kreiger'*, which translates as the frankly terrifying 'badger warrior'. Five hundred years ago, nobody laughed at this bad boy.

In hunting circles, the badger warrior was a hound that could be appreciated in segments from one end to the other. While slightly bigger than the dog that we know now, it was no less distinctive in shape. Starting at the front end, this courageous canine possessed a pointed nose, muscular chest and paws like mining shovels. Head on, it was effectively a living, breathing excavator. Through careful and selective breeding, encouraging a sense of purpose, pluck and courage, the hound proved machine-tooled for opening up rabbit warrens, fox holes and badger setts. Even those long, flappy ears were bred in to help keep out soil, spores and grass seeds.

Moving to the mid-section, the dog's long, lean torso was purpose-built to wriggle into tight spots, with loose skin to reduce the risk of tearing on its mission to pull out prey. The back end wasn't much to write home about, with the breed sporting the canine equivalent of frog legs. Even so, these crooked little stubs provided something for the hunter to grab in order to haul the hound out of the ground. Even the curved tail could prove to be a useful anchor.

Design-wise, the early dachshund was a lean, mean forest predator. As hard as it might be to get our heads around this idea now, it was the ultimate hunting companion.

In packs, this forerunner of the modern sausage dog found strength in numbers. Back then, a pack of badger warriors was capable of tracking wild boar. They'd

flock through tangled undergrowth, flushing out their quarry before taking it down. The dog was revered by hunters but had lofty ambitions. Over time, it crept into royal courts across Europe. Perhaps the most famous dachshund disciple was Queen Victoria, who owned several over her lifetime, including the grandly titled Waldman VI and his consort, Waldina.

It is perhaps this combination of hunting origins and centuries spent yapping at royal servants that forged the temperament of today's dachshund, or wiener dog as it's also known. While the breed has evolved into the standard and miniature variety (basically different degrees of dinkiness), with short-, wire- and long-haired editions, it's still a wildly spirited dog with an elevated sense of its own importance.

So, how does this mix of energy and entitlement translate to the modern dachshund's approach to work? In short, the sausage dog will tackle any task wholeheartedly, but only if it chooses to do so.

In total, Hercules attended two dog-training classes. After the first one I assumed he just needed time to settle and recognise that the teacher expected him to at least attempt to follow instruction.

He was only a puppy at the time. He'd been part of the family for about a month, during which time responsibility for his basic upkeep had fallen to me. By extension, this applied to his schooling. Our German shepherd, Sesi, had failed to step up as a tutor by then, and continued to regard Hercules with an air of disbelief that he could even be classed as a dog at all. So I'd enrolled us both on a course in the hope that it would help him to fall into step with me. I didn't think he would learn basic commands straight away. I had just assumed that, like the other young dogs in the class, he'd make an effort. While a few flopped and goofed in response to a command to sit, wait or walk to heel, most figured it out within a short space of time. Only Hercules flatly refused to make an attempt.

'In short, the sausage dog will tackle any task wholeheartedly, but only if it chooses to do so.'

'Is your puppy motivated by food or toys?' asked the trainer earnestly. She had approached me with a felt python in one hand and some kind of treat holster slung around her waist. I glanced down at Hercules. He looked up at me as if I should know the answer.

'Toys?' I said with little conviction. I just figured that, had the question been asked about me, I wouldn't want people to think I was ruled by my stomach.

The trainer considered me for a moment. Her eyes narrowed.

'Let's try a biscuit,' she suggested, positioning herself midway across the room.

For a good minute, I watched as the trainer held out her treat and made encouraging noises at my sausage dog in vain. Then she tried to coax him in the same way but with the soft toy snake.

Hercules regarded her as if she'd lost the power of adult speech.

'We're going to need a bigger biscuit,' I joked feebly.

'Hercules can just watch the others,' she said, which sounded like face-saving to me. 'He's just nervous.'

For a young pup allegedly suffering from self-confidence issues, Hercules seemed miraculously cured when it came to going home. He walked to heel on a loose lead, head held high as he cut a path through the other puppies as if they'd never progress beyond chasing their own tails.

On the second visit to puppy training, I was wise to the fact that Hercules knew exactly what was being asked of him. At home that week, hanging out with the family, I had witnessed him perform all the basic tasks with ease. Our sausage dog could wait on command, sit and steer clear of Sesi if she was in a mood. The only difference was that he elected to do them on his own terms. If he wanted to sit, then he'd do exactly that. He'd also respond to his name as long as it suited him. When commanded, a selective deafness kicked in, and that would only deepen if anyone chose to really test him on it.

Returning to class, Hercules metaphorically tossed the teacher a bone by sitting for a tasty treat, only to rise as she turned away and shoot me a look as if to inform me that his formal education was now at an end.

I didn't give up on lessons because my sausage dog was a lost cause. On the contrary, he could already perform the tasks required of him. If anything, attending those two sessions had taught me that a dachshund is very different from any other breed, and thrives on being handled accordingly. Unlike other dogs, it wasn't a question of issuing instructions at him. Instead, if I wanted Hercules to do something, I got the best results by levelling with him and then seeking some kind of compromise.

'I know it's raining,' I said as we pulled up outside the house after our final time at dog school. 'It'll take all of thirty seconds to hop out of the car and get inside the house ... OK, what if I carry you? Is that all right? Yes, I'll be quick ...'

So, the dachshund is a working dog. I just had no desire for Hercules to seek gainful employment. My priority was for him to fit around *my* working day, and this is where the sausage dog comes into his own. In fact, so long as nobody else is around to cast judgement, I discovered that the breed makes the ideal office colleague. Over the years I have learned a great deal from Hercules's outlook on the nine-to-five grind. While any badgers in the woods nearby can sleep safely in their setts, the contemporary dachshund has evolved to boast a skillset suited for the modern age ...

'With a sausage dog trotting merrily at my side, I'm reminded that there's more to life than clattering at a computer keyboard.'

## Supervision

Working from home, in a room to the side of the house, I find Hercules is always first in the office. I shuffle in with a coffee in hand to find him stationed on the sofa with a disapproving look. Dachshunds enjoy human company, after all. They're not lap dogs, but they do like to watch over their owners as if they're incapable of taking care of themselves.

'I'm not late,' I often reason, before glancing at the clock. 'Not massively.'

My sausage dog continues to monitor me until I have finally settled at my desk. It feels as if I can't afford to waste any more time under his watch. In some ways, this poised, prim dachshund has come to represent my guilty conscience, and so I knuckle down to work to make up for lost time.

Hercules's flair for supervision also extends to the cat, who generally saunters in hours late without a care. While the dachshund may permit some flexibility in timekeeping, this is obviously unacceptable and the cat is duly chased away.

## Team Building

As well as calling the shots during office hours, Hercules knows how to pull his colleagues together when it matters most. Sometimes he'll catch me staring dolefully out of the window, stuck on a task and pondering my next step. If the cat has made it to work on time, then chances are he'll be stretched out on the ledge. I might reach forward to stroke him, which naturally triggers the sausage dog's in-built jealousy sensors. Within seconds, Hercules is at my feet, vying for attention. With each arm stretched to fuss with a pet, I then find myself in the working-from-home equivalent of a group hug. Which always feels revitalising.

## Prioritisation

From time to time, we can all become overwhelmed by work. When the demands mount up, it's easy to lose sight of what needs to be done. Sausage dogs are excellent at establishing a pathway through it all, and even leading the way. If I'm working to a deadline, struggling to deliver a piece of work on limited time, Hercules is on hand to guide me through it.

What's required, through the eyes of the dachshund, is a walk.

It doesn't matter how pressed I am; Hercules will present this to me as the only option. He expresses this by hopping off the sofa, standing by the office door and barking. Nothing will stop him until I give in with a sigh. Aware that deadlines are looming, I swear that sometimes even the cat rolls his eyes.

I might leave the house with reluctance, feeling suffocated and stressed, but within minutes I find that Hercules has made the right move. In the fresh air, with a sausage dog trotting merrily at my side, I'm reminded that there's more to life than clattering at a computer keyboard. What's more, once I'm back at my desk, a clear head means I can cut through the work in no time.

## BE MORE SAUSAGE

**The dachshund is effectively a working dog that has just downsized physically.** It's not afraid of hard graft but understands that there's more to life than the nine to five.

This is a breed prepared to get the job done, unless it can be delegated. The sausage dog is adept at finding supporting tasks to be doing, such as keeping the sofa warm while you get on with the housework or guarding the house from the distant hum of a lawnmower.

Being more sausage in the workplace is about appearing to keep busy, and making a big drama out of it, while effectively doing the bare minimum. At the same time, be as supportive as possible towards your colleagues. Aim to be at the heart of the task in a way that means everything is undertaken by others and yet people feel they can't manage without you.

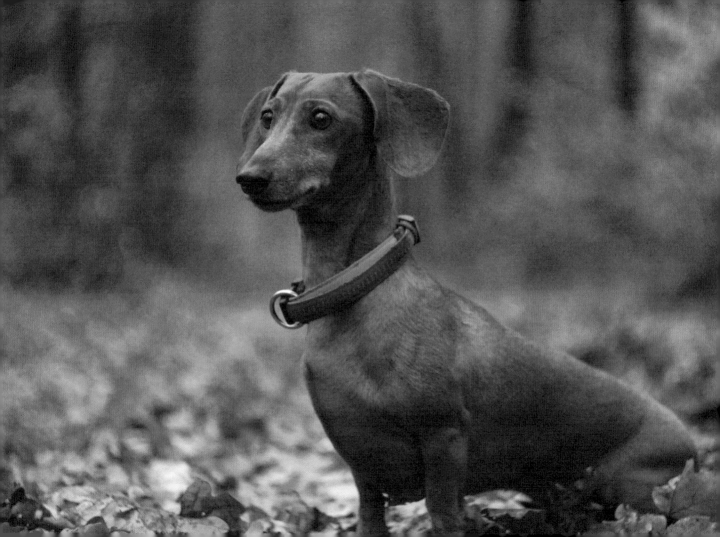

'Curled up like a cinnamon swirl, its body language speaks loud and clear. It becomes a living, breathing *DO NOT DISTURB* sign, which is something we could sorely use ourselves.'

## AT REST

All dogs know how to make the most of downtime. It's one of their defining characteristics. Whether they've had a tough day or done nothing at all, they can always switch off from the world around them in a way that we can only envy.

When it comes to curling up, however, the dachshund takes things further than any other breed.

It's one thing for a regular dog to circle its bed before sleep, but the dachshund's long body means it requires a few extra turns to feel snug. As the dachshund curls up like a cinnamon swirl, its body language speaks loud and clear. It becomes a living, breathing DO NOT DISTURB sign, which is something we could sorely use ourselves.

At the same time, the dachshund's small size can make it vulnerable at rest. If I walk into the front room and find Hercules shaped like a dinner plate on my favourite spot, I can simply pick him up and relocate him. He's as portable as a handbag, and yet there is a reason why I should let this sleeping dog lie. It isn't because he's a primal creature, descended from the wolf, and you wouldn't mess with one of those if it happened to be dozing on your sofa. Hercules might growl his displeasure, but that's as far as he'd ever go. Even so, I'm wary for a different reason, which comes down to the dachshund's conviction that it should be treated as an equal at all times.

I learned my lesson when Hercules was young. He had taken to curling up on my side of the sofa. In response, I was busy training him to recognise that it was out of bounds by shifting him to one side whenever I wished to sit down. At first, it seemed as if the dachshund was slowly learning his place. As it turned out, he was simply awaiting the right moment to correct *my* behaviour.

As well as curling up on the sofa, Hercules sometimes deploys a secondary resting position, which basically involves stretching out from nose to tail somewhere deeply inconvenient. I was hurrying downstairs when my day of reckoning arrived. He had switched from the

sofa to one of the upper steps, and I only registered his presence having already committed my foot to the step in question. In a split second, I realised I was either going to cause great harm to Hercules or somehow force an overshoot and cause great harm to myself. Hercules knew full well I would instinctively avoid the former and simply watched me as I tumbled headlong down the stairs to the hallway floor.

With my foot encased in plaster for the next six weeks, and a crutch under each armpit, I found the sofa to be so low that it was off limits to me. For Hercules, it was a chance to occupy my spot without the risk of being moved on. All I could do was perch on the hard chair across from him and reflect on how we had arrived here. Occasionally, the sausage dog would stir from sleep and peer at me. Depending on my mood, it was a look that could be read either as compassion and pity or satisfaction from a lesson learned. My training in this field, it seemed, was complete.

Now, we can only dream about the close relationship all dogs have with sleep. With frequent naps throughout the day, they're constantly topping up their internal batteries to full charge. It means that, rather than struggling through to bedtime, becoming increasingly tired and crabby, they can throw themselves at life at all hours.

Being small and seemingly too cute to care, the dachshund appreciates this more than any other breed, and jealously guards its right to snooze on its own terms. The hound is aware that its portable size makes it vulnerable to being moved, which is why it goes to great lengths to defend its right to be left in peace. As owners, once we have become aware that the sausage dog will bite back in unexpected ways, we leave it to enjoy this precious downtime.

Let sleeping dachshunds lie, because if you don't, frankly you could die.

## BE MORE SAUSAGE

**We may not be able to curl up in a way that sends out a clear signal that we shouldn't be disturbed, but we could learn to be a little more vengeful.** There's no need to go full dachshund here. Nobody deserves to get hurt over lost sleep. It's just a question of making your napping needs known in advance, with just a veiled threat of painful consequences if you're woken. This way, people will understand how important it is to you and provide all the space you need in order to surface in a positive, caring and fragrant mood.

## AT PLAY

Some people in life are purpose-built for certain sports. From rugby props to steeplechase jockeys, we find that our physical make-up can go a long way to giving us an edge. The same can be said for dogs when it comes to playing games. If a breed is built for speed, like a greyhound or a whippet, then a tennis ball can provide endless fun, while a compact and nimble dog like a terrier or Border collie can make light work of an agility course.

Boasting no physical advantages in any shape or form, the dachshund doesn't look like the type who should possess a competitive spirit. In fact, this is a dog who approaches any kind of fun task with a singular view: to win at all costs.

If friends or wider family come to visit us and bring a dog in tow, we'll spend time making it feel welcome. Our German shepherd was accommodating, so long as she knew the new arrival had a home to return to. The dachshund just assumes a four legged-cuckoo has arrived in the nest. To help the guest settle in, we'll often break out toys that Hercules never shows an interest in, like his rope tug. All of a sudden, however, this neglected cord section with a knot at each end becomes his prized possession. If the visiting dog is bigger, which is almost always the case, Hercules will guard it so jealously that I have to intervene and encourage him to share.

'You can both have a go,' I remind him, and invite the visitor to take hold of one end. 'Now, play nicely.'

What follows is not so much a tug of war as a total defeat for the dachshund. Despite digging in, with his jaws chomped around the rope, he'll find himself briskly swept around the kitchen by his opponent like a canine floor mop. It's amusing to watch, though possibly less so to experience first-hand, and yet Hercules will never let go. Instead, he'll allow the other dog to reach a point of exhaustion or boredom until he gives up. Then, the sausage dog will scamper off with his prize, only to dump it two seconds later, having claimed a victory of his own making.

## BE MORE SAUSAGE

**A natural-born underdog, the dachshund understands what it takes to win at life.** Gaining the upper hand is not about skill or physical strength. It's about sheer bloody-mindedness. Even in the face of defeat, there are always points to be scored from the experience.

Yes, it can be seen as belligerence, but let's look at play through the eyes of the sausage dog. When the odds are stacked against you, the taking part just isn't fun. What our disadvantaged little friend is doing here is creating hope where there is none, which is an outlook that could benefit us all.

'A natural-born underdog, the dachshund understands what it takes to win at life.'

## BE MORE SAUSAGE

**A natural-born underdog, the dachshund understands what it takes to win at life.** Gaining the upper hand is not about skill or physical strength. It's about sheer bloody-mindedness. Even in the face of defeat, there are always points to be scored from the experience.

Yes, it can be seen as belligerence, but let's look at play through the eyes of the sausage dog. When the odds are stacked against you, the taking part just isn't fun. What our disadvantaged little friend is doing here is creating hope where there is none, which is an outlook that could benefit us all.

'A natural-born underdog, the dachshund understands what it takes to win at life.'

## THE COMPLETE PACKAGE

Like any domestic dog, the dachshund thrives on routine. Punctuality is important in the workplace, for example, in the sense that Hercules is a canine colleague who can make me feel really guilty for switching on daytime TV. Rest and play are equally central to this dog's life, so long as it doesn't feel robbed of sleep or a victory when it comes to games of every kind.

In short, with the day marked out from dawn to dusk, the sausage dog will thrive.

It's quite capable of taking on unexpected challenges and adventures, of course, so long as food and board is built into the programme.

### BE MORE SAUSAGE

**Despite its length, the dachshund is not a dog for half-measures.** In its own particular way, it throws itself wholeheartedly into work, rest and play, finishing every day fulfilled. We can follow in the sausage dog's footsteps by establishing a routine of our own and then tackling each task with gusto. It's the surest way to build a sense of achievement while creating the confidence to take on unexpected challenges and see where the adventure takes us. Attitude is key here. If you look like you're ready for anything, that's half the battle won.

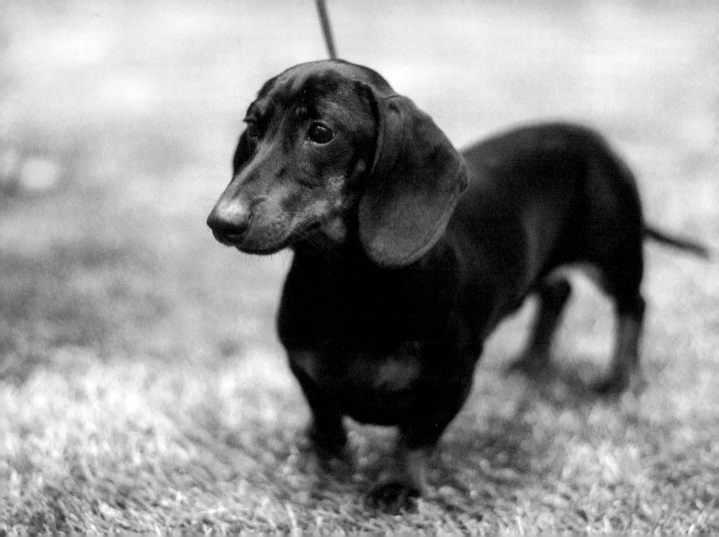

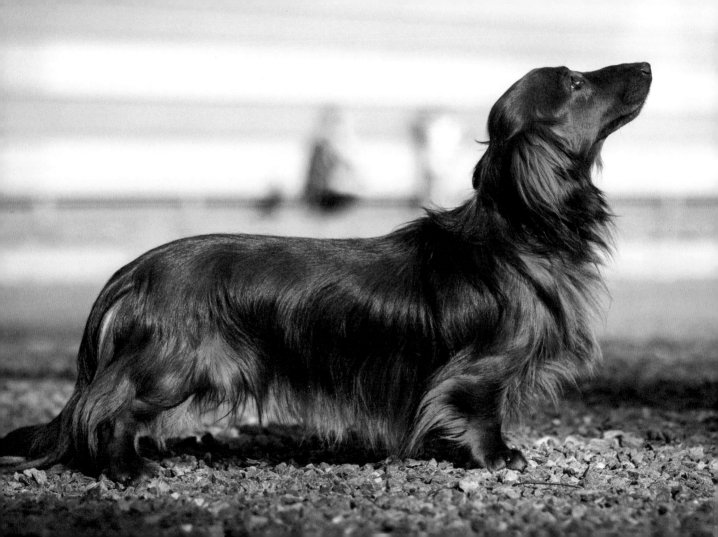

# 2. ONE-OF-A-KIND MIND AND BODY

Aim low for a moment and imagine you're a dachshund. Compared to your fellow dog breeds, your proportions appear to be the result of some kind of evolutionary oversight. You can't walk through long grass without disappearing, and sharp corners are to be negotiated with all the skill of an articulated truck driver. Everyone considers you with an air of amusement and pity, and that includes cats. As the realisation takes hold that life is going to be a challenge in every conceivable way, it would be easy to let your confidence slide and all manner of self-doubt seep in.

In reality, the dachshund is far from an anxious dog. Nor is it shy or reclusive, hiding away from a world in which it struggles to fit in. We're not dealing with a semi-mythical creature here, limited to rare sightings before it scuttles back into the undergrowth. We have no need to create a protected environmental area as if it's some kind of canine panda. The sausage dog walks among us, admittedly as a trip hazard, but does so with its head tipped proudly. By rights, this dog has no business behaving with such assurance.

Perhaps most strikingly of all, the dachshund is more content than most of us could hope to be. In fact, it's notably balanced in character. Some breeds, such as the springer spaniel, are permanently excitable, as if wired to blow up like the bus in *Speed* should they ever slow down. Conversely, it could be said that dogs such as the Labrador never quite break out of snooze mode, even in the face of extreme stimulation. The dachshund occupies the middle ground. It's neither hyper nor horizontal in attitude. In every sense, it's a dog that's perfectly grounded.

So, what's going on here? How does a sausage dog rise above its limitations so successfully? What allows it to be so equitable and comfortable in its own skin? Most importantly, are there lessons we can learn from the dachshund to improve our own quality of life?

'If we just stopped for a moment and looked down, we'd see the way forward at our feet.'

## WEINER WELL-BEING

Be kind to yourself. That's good advice when it comes to making your way in the modern world.

It's also easy to forget when the stresses and strains of life mount up. If you're running around from dawn to dusk, juggling demands at work and home, you might catch sight of your own reflection and see a tired, wrung-out stranger. Sometimes we keep pushing until we crash, which is no way to enjoy a fulfilling existence.

Yes, there are therapists and guides to help us reclaim control of our lives. There is also an alternative source of inspiration that's much closer to home. If we just stopped for a moment and looked down, we'd see the way forward at our feet.

The dachshund might not seem like the first port of call when it comes to healthy mind management. Then again, when did you last see a stressed-out sausage dog? Whether it's enjoying a morning nap or sending a squirrel scurrying back up a tree trunk, it's always in control of its emotions. This is a breed that truly understands itself at all times. There's no way it can ignore its shape and size, and yet we have a hound that remains quite comfortable with its identity.

To further understand this, let's stop chuckling at the sausage dog for a moment and appreciate just how it has come to be so at peace with itself and the world around it.

The back door to my house is scarred in two very different ways. Just beside the handle, the deep vertical grooves look like a short-lived attempt by a werewolf to gain entry. Sesi only scratched to get in once, rising up on her hind legs to drag her claws down the woodwork. I imagine my dismay made her rethink her actions and modify them accordingly, because from then on she simply barked to be let in. Today, I view those claw marks with some fondness. They add character, I think, and remind me what it was like to own a dog that did as it was told.

Then there is the damage at the very foot of the door. This is also down to a dog demanding to be let

in, but it's far from a one-off. Over ten years, despite every attempt by me to teach him otherwise, Hercules has scratched at the woodwork so frequently that he's basically worn it away. It's a smooth, depressing little basin I have repaired with wood filler and repainted on several occasions, only for the dachshund to repeat the process all over again.

Why does Hercules keep doing it? Because this is a dog that solely exists in the present. There is no scope for regret or anxiety about the less-than-impressed welcome he's guaranteed to receive when I open the door for him. I can crouch down and draw his attention to the consequences of his actions. In response, Hercules just looks at me because I'm in the way, and then trots in merrily when I finally step aside.

This mindful approach to life isn't supposed to be annoying, and it's far from that for Hercules himself. For my little sausage dog, the here and now is all that matters. If that means pawing the door to gain entry, then so be

it. Through his eyes, it isn't an act of disobedience or disrespect. It's just the most effective, fun and satisfying way to summon my attention with no care for the past or future. By the time I open the door, peering down at him with lips pursed '*because we have discussed this*', Hercules will have moved on to the next moment, which involves greeting me with a hearty wag of his tail.

We live in an age of anxiety. In today's world, worry and stress are constant companions. We fret about everything from our actions to our image. Such concern about how others see us can then restrict our true selves.

Sometimes we need to be reminded of what life can be like either when nobody is looking at us or we simply don't care, which is where the dachshund leads by example. It's true that dogs don't tend to worry about paying the bills or growing their Instagram profiles, and yet this particular breed is more mindful than any other. It doesn't just live in the moment, untroubled by what has gone before and what lies ahead. It positively owns

the present. In the now, there is no room for regret or trepidation. For a hound universally ridiculed for its body shape and size, this is quite some achievement.

In some ways, Hercules forced me to become more mindful when I first set out on dog walks with him. Rather than keep my eyes peeled for people, fearing what they might think, I forced myself to be more like my four-legged friend. It took a while to enjoy stepping out without reservation, but once I'd learned to let go, I never looked back. If anyone wished to judge us, that was no longer going to stop me. I learned to be so unconcerned by what people might think that I stopped changing into my 'walking jeans' before stepping out with Hercules in favour of the chequered lounge pants favoured by so many home workers. Matched up with my wife's pink Crocs on the occasions when I couldn't be bothered with boots, I simply didn't care, and the sense of freedom was life-affirming.

## BE MORE SAUSAGE

**We are often encouraged to be more mindful, but only doing it like a dachshund will take you to a truly harmonious place.** This is a dog so long that it effectively exists in two different time zones. It would be all too easy for it to get caught up in where it's just been, given that its hind legs are likely to still be there. In the same way, you would think that being so low-slung must mean the hound faces a sense of foreboding about what lies ahead. In reality, rather than getting strung out about the past or future, the sausage dog just devotes itself to the present – and makes sure it comes out of every moment on top.

We may not share the dachshund's physical peculiarities, but we can still adopt the same outlook. It's not just about taking life as it comes, as the mindfulness expert will say, but demanding that life makes way for you.

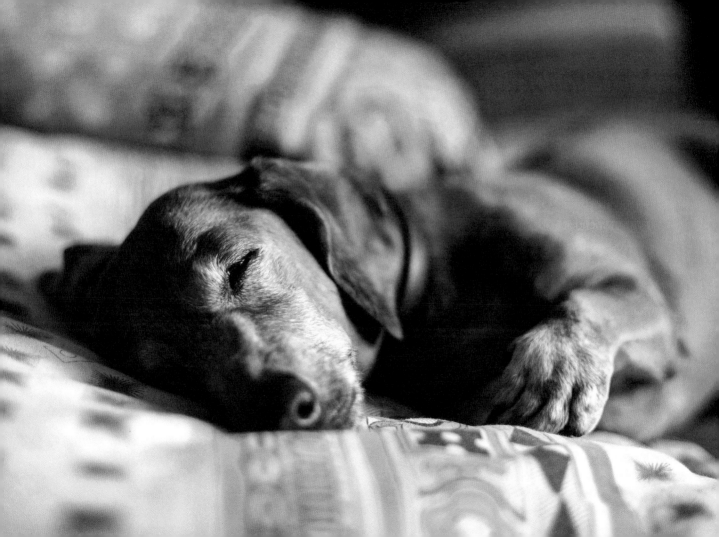

## ALL THAT BODY CONFIDENCE

It's important that each and every one of us is comfortable in our own skin. Being at peace with our appearance is vital when it comes to allowing our personality to shine. This is all very well in theory, of course, but in reality all manner of worries about the way we look can hold us back in life. From head to toe, there are always bits of our own bodies that disappoint us. As a result, such wobbles can become the focal point of our thoughts, and even distort our perception of how others view us.

So, what does the sausage dog see in the mirror? On paper, you would expect the poor soul to take one look and despair. For there isn't just a single aspect of its appearance that seems a little out of proportion here. From nose to tail, its entire body is at odds with itself. Despite this, when the dachshund comes face to face with its own reflection it shows no misgivings whatsoever. If anything, this is a dog that appears to be emboldened, which is a mindset so many of us can only dream about. When you're less than six inches high, with a body that won't fit side on within the boundaries of the mirror's frame, this is quite a remarkable achievement.

This self-assurance is striking, but it isn't down to what the sausage dog sees reflected in the glass. It looks beyond that, as if somehow its spirit is visible to the canine eye.

This little hound even seems to have found a way to overcome the insecurities we experience when comparing ourselves to others. Standing shoulder to knee with beefcake breeds such as the vizsla or ridgeback, you would expect it to cower and offer up compliments to stay in favour. Instead, in the presence of such classically handsome specimens, the little dachshund puffs out its chest and takes charge of the situation. It's an admirable quality, and one we could all benefit from acquiring.

## BE MORE SAUSAGE

**The dachshund isn't a delusional dog.** It might possess the character of a breed six times its size, but this is no front. Its confidence comes from the heart. No matter what our appearance, we can all see life in the same way. It's simply a question of recognising that our body shape is just one aspect of who we are. It might be the first thing others notice, but it's what's inside that creates the lasting impression.

When it comes to self-awareness, the dachshund quite simply has no concerns about its physical appearance. It just regards itself as a dog with a lust for life and expects others to see it through the same eyes. That extends to owners like me, new to the mortifying horror of walking a sausage dog in public, and is the reason why I learned to quickly follow in the footsteps of my assured and carefree canine companion.

## RELAXATION

For a dog that can practically turn itself inside out in a frenzy when the pizza-delivery guy knocks at the front door, the dachshund has a vested interest in stress-management strategies. Without some means of dialling down the drama every now and then, it would be like one of those permanently touchy breeds, such as the Pekingese, that devote their entire existence to being angry at life for no reason.

The sausage dog certainly knows how to kick off, but it's also adept at coming back down to earth. For the dachshund, anger is a healthy emotional release. It's a cathartic experience that brings a sense of peace. In a way, it's all part of the relaxation process. What matters to the hound is that nobody gets hurt or upset when it does fly into a rage, which is why it selects its targets responsibly. Children and the elderly tend not to receive the full force of the sausage dog's displeasure, for example. Instead, the dachshund identifies threats from individuals who no doubt consider it to be a hazard of their jobs, such as delivery drivers and cold callers. Then there are things that might seem harmless to us, but which somehow insult the very core of the dog's being, such as a breeze rustling leaves in a tree. Such moments might be explosive, but they're also over very quickly. Having got things out of its system, the sausage dog is able to move on.

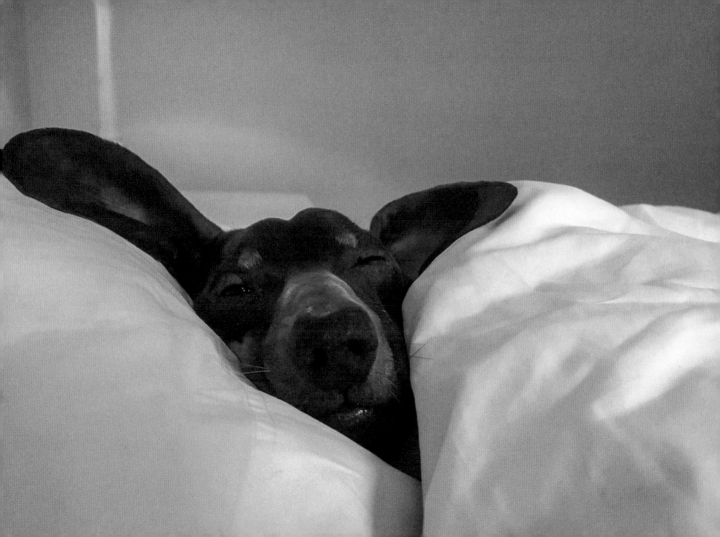

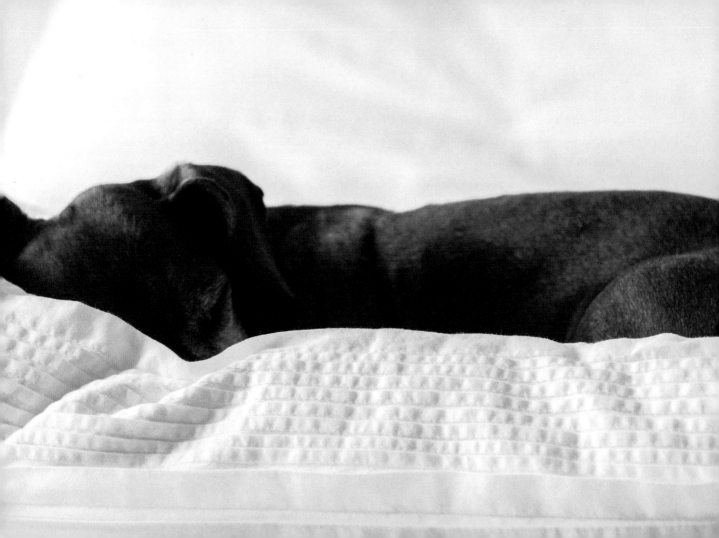

## BE MORE SAUSAGE

**Relaxing is all about finding ways to scale back the tensions in our life that can threaten to overwhelm us.**
Bottling up our feelings and hoping they'll fade is no solution. That's how we end up transforming into human wrecking balls. The dachshund is well aware of the importance of stress management. Rather than seeking to turn down the temperature and chill, however, this is a dog that opts to burn it all off in one brief, spectacular blaze. It's an unconventional means of finding peace and tranquillity, but effective.

So, next time you're at breaking point, why not consider cancelling the yoga session and de-stressing like a dachshund? This doesn't mean taking it out on anyone who dares to knock at the door. There's no need to go full sausage here. Instead, take yourself off to a place where nobody is going to be upset by your outburst, such as a beach or remote woodland, and then yell at the top of your voice. Go nuts, turn in furious circles and then breathe. It feels great, nobody gets hurt and you can return to your life with a sense of calm restored.

## FOOD AND SNACKS

Your average dog considers a bowl of food as something that needs inhaling. It's as if it fears that any pause or hesitation in wolfing it will disqualify it from further meals.

There are no manners here, and little enjoyment. It's about ingesting what's on offer at breakneck speed then madly licking the bowl in the hope that more food might magically materialise. By adopting a more measured approach to eating, the dachshund effectively dines at a higher table. It is perhaps the likeliest of all dog breeds to inspect a serving, sample a bite and then turn away.

When Hercules first declined a breakfast of dried kibble, I worried he was unwell. I checked him over. I even picked him up then plonked him in front of his bowl. He simply looked at me pitifully and took himself back to bed.

By suppertime, concerned that he may not survive the night, I caved in completely. The addition of freshly cooked peas and a few splashes of gravy persuaded Hercules to force a few mouthfuls down. Even so, he didn't finish it off like a normal dog. Instead, he returned to pick and nibble throughout the evening.

So, what's going on here? Well, I had been totally manipulated. When it comes to grooming owners for a better meal deal, the dachshund has more in common with a cat than its fellow breeds. It can hold out for days, presumably calling upon fat deposits carried in its extra-long torso for survival, until finally you give in and serve up something more agreeable. In my experience with Hercules, this would be food from my own plate. In his view, we are equal partners, although I feel more like his personal taster. Failing that, he'll settle for dog food at the lofty end of the price range; the gold-seal pouches that contain venison or some kind of artisan swan substitute.

What's more, having secured the upgrade in quality, the sausage dog is in no rush to consume its food. It's something to be savoured and enjoyed, not in one sitting but throughout the day. In effect, the dachshund has mastered the art of snacking.

## BE MORE SAUSAGE

**Eating three square meals a day is not to everyone's taste.** Maybe it doesn't fit well in your busy life, or you have no appetite to sit around a table making conversation. The dachshund understands this and has thrown off convention without a care.

This is a hound that ensures food standards remain high and eats alone when it pleases. One or two mouthfuls at a sitting might seem picky, but it's never a chore or a race against time. There are also some benefits to grazing through the day in this way. A steady intake of healthy snacks regulates energy output, which can help improve focus and productivity. It can also minimise the risk of a post-lunch slump.

The key, if we are to be more sausage about the experience, is to maintain a high-quality snack routine without any sense of guilt. Life is too short to care about what other people think. This is about taking the most pleasurable and indulgent way to eat and transforming it into a complete diet.

# 3. THE EMOTIONAL SAUSAGE

For a little dog, the dachshund has a very big heart indeed. It's a loyal and loving companion that's never far from your side. This connection with people, coupled with a smart brain, should make it an ideal candidate as an assistance dog. So why don't we see any in service?

On paper, the dachshund should sail through the exams to serve those who rely on canine help. As well as forming a close bond with its owners, it is perfectly capable of learning domestic chores such as pulling laundry from the washing machine or opening curtains.

There is a high bar to qualifying as an assistance dog, but the dachshund doesn't fail for obvious reasons. Being close to the ground could have significant advantages, in fact, when it comes to raising the alarm about trip hazards. The problem lies in its emotional make-up. For this is a role that requires the candidate to be cool under pressure and selfless at all times, which it isn't. Even if an uncharacteristically servile dachshund cleared this hurdle, it would fall short on account of its ability to hold a grudge.

The lengths to which it'll go to guarantee a good sleep shows this is a dog that likes to get even. If the dachshund is wronged in any way, it never forgets, which isn't great if you're in a bad mood and relying on your assistance sausage to guide you across a busy road.

While the dachshund might not come up to scratch as a service dog – and frankly a couple of inches of snow rules out any opportunity to rival the St Bernard in alpine rescue – we can still learn a lot from its mind state. In general, we frown upon people who cannot forgive and forget or become unreasonably hung up on some perceived injustice. We consider them unable to see the wood for the trees, yet we're talking about a dog that can't see the trees for the undergrowth. However, the dachshund remains a popular pet that also inspires respect from other breeds. Its emotional peculiarities seem to work for it just fine.

In short, having a reputation for getting even encourages others to treat you as you treat them. So long as you maintain a high standard, you're entitled to seek payback if they fail to match it. Ultimately, your reputation for punishing unreasonable behaviour means people are forewarned. With the foundation for the sausage state of mind established, what other emotional characteristics could we learn from this unique dog?

'The dachshund might look like a comedy act, but the fact that as a dog breed its backbone is proportionally longer than any other dog breed's speaks volumes.'

## THE ART OF BRAVERY

The default dog when it comes to courage has to be the German shepherd. The combination of physical shape, strength and size, intelligence, temperament and fierce loyalty make it a four-legged friend you can trust to drag you from a burning building.

In short, the shepherd looks the part. The same can be said for the Dobermann and Rottweiler; two breeds that are also no strangers to wearing medals around their broad, muscular shoulders. These are natural-born hero dogs. If they were human, we'd be looking at lantern-jawed leaders more likely to press a bench than sit on one. In their company, no quarter is off limits. You might as well be walking around with a chainsaw. Nobody is going to mess with you.

With a sausage dog at your heels, it's easy to think that a walk through town would take longer on account of all those seedy cut-throughs you'd have to avoid. The truth couldn't be more different. The dachshund might look like a comedy act, but the fact that as a dog breed its backbone is proportionally longer than that of any other speaks volumes. When faced with a threat, no matter how intimidating, this is a hound that will never turn tail. Not straight away, at least …

For the little dachshund, bravery is all about putting on a front. It's first to kick off, and does so by exploding into a volley of furious barks. If that's all you hear, without laying eyes on the dog responsible, it can sound terrifying. It's playing to its strengths, of course, with a pair of lungs so powerful it can actually hurt to be within earshot. I have seen delivery drivers cower outside my house when Hercules detects their approach from the hallway. It's only when I open the door, having scooped him up, that they breathe out in relief. What they don't do, however, is laugh. I might see a glimmer of amusement in their eyes, but by then the sausage dog's sound-based shock-and-awe campaign has achieved its aim. Yes, it looks ridiculous, and yet the seed of doubt has been cast.

'You can try,' snarls the dachshund from under my arm, 'but you'll be sorry.'

It is, of course, a massive front. A means of making up for the fact that it lacks the same physical presence as your classic courageous canine. There is a reason why we never see footage from police dog-training school of a sausage dog taking down some poor sap with a padded arm. The will is there, but size-wise it lacks the way. If the dachshund is quick to make a big noise, and even give chase when required, ultimately there is a limit to how far it'll go. Here, self-preservation kicks in. Despite a wide turning circle, the dachshund can reverse direction in a heartbeat. This happens when the apparent threat decides to stand its ground. Should a face-off occur, the sausage dog will continue to make a big noise, but from a safe distance. Even if it has to keep backing up, that's fine. It'll just continue to bark wildly until the object of their attention decides it's simply not worth the risk.

# BE MORE SAUSAGE

**On bravery, the dachshund is a master of the bluff.** It plays to its strengths, which effectively makes it all mouth and no trousers, but the strategy works. Whatever our shape and size, this is an effective approach in facing danger. The key is to come across as fearless without actually being put to the test.

It's all about first impressions. For the sausage dog, it's vital that people register its considerable sound and fury before acknowledging the physical long- and shortcomings. This way, nobody dares to even chuckle. They want to, of course, but what if this really is a savage fighting machine that just happens to be trapped inside the body of a dog designed by a toddler? Caution is always going to win the day.

Ultimately, if you want to be brave like a dachshund then step forward first and make it known that you know no fear. By creating a massive drama out of the moment, you might even begin to believe your own hype. And if you're forced to retreat in the face of aggression, then dress it up as a charitable regrouping. Let your inner sausage dog make it known that you could strike with devastating force, and that there will be tears if you're seriously provoked ...

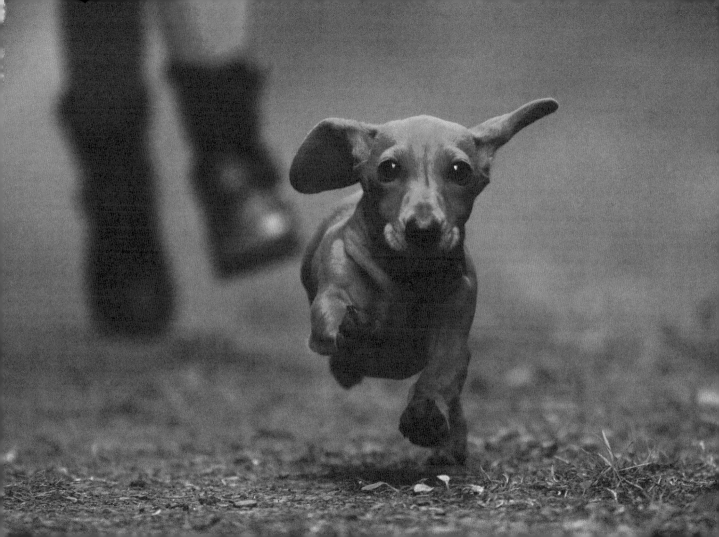

## EMBRACING ENVY

It's one of our seven deadly sins but a guiding principle for the dachshund. In this dog's world, envy is an emotion that ensures the little guy never loses out.

Whether we've experienced a twinge or found ourselves consumed by it, envy is nature's way of reminding us that we deserve better. If our neighbour has something that's bigger, more beautiful, more desirable, shinier or just nicer than anything we possess, from worldly goods to kids that behave better than ours, we're bound to compare our lot in life to theirs and come up short.

Morally, we're supposed to rise above this kind of thing, but let's not fool ourselves here. We can't help but seethe. Even if we're in denial about it while chatting merrily over the fence, a voice inside our head is on hand to remind us that if a sinkhole opened up and swallowed half their house, we'd quietly consider justice to have been served.

Where we go wrong is by not acting upon our feelings. Instead, we allow that resentment to take root and fester. Slowly, that negative thinking begins to creep into all aspects of our lives. It can undermine our confidence, our focus, the very purpose of our existence. One day we note that they've got a new widescreen. Within a month we've lost everything and are living in skips.

The sausage dog doesn't allow itself to be consumed in this way. Instead, it considers envy to be a call to action. Yes, it will bristle if guests arrive with a dog and bring a bed that looks more comfortable than its own. Rather than retreat and sulk, however, the dachshund will simply bide its time. At some point, the visiting dog will have to get up to eat or exercise, and that's when it'll make its move.

By the time the dog returns, it'll find the dachshund has claimed the bed for itself. If the poor guest even politely signals that there appears to have been a mix-up,

the sausage dog will suspend all etiquette as host and bark at it to back off. Through the eyes of the dachshund, a breed with a high entitlement drive, the bed has transferred ownership. It leaves the visiting dog with no choice but to squeeze into the dachshund's bed and wish it was time to head home.

## BE MORE SAUSAGE

**Nobody is advocating theft here.** If next door purchases a nice new car, we can't just hotwire it at night and drive off. What we can do is unleash our inner dachshund and take action – just in a more constructive way than stealing.

So, instead of stewing, ask yourself why you're feeling green. Rather than focusing on their flash car, look at your life and identify aspects that you wouldn't trade in for the world. It's the surest way to be grateful for what you have, and will help you become a better person.

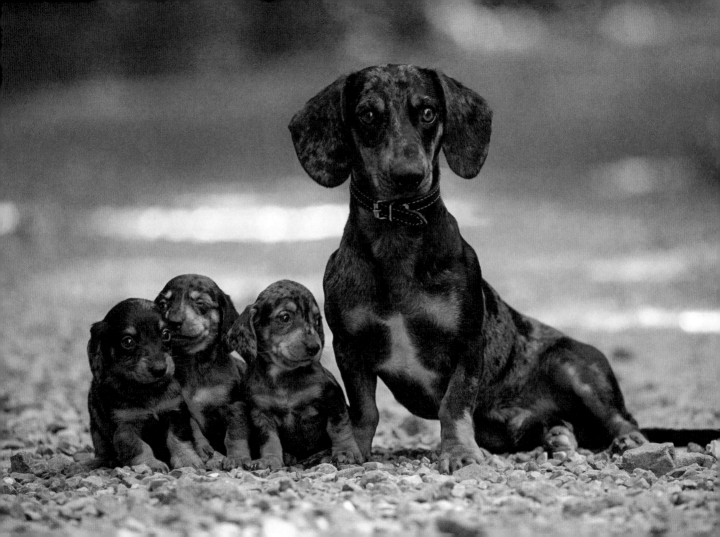

## POWERS OF PERSUASION

You can lead a horse to water, but good luck when it comes to doing the same thing with a sausage dog. Even if you presented it with a lake of gravy, this is a breed that will decide on its own terms when it's time to visit the shoreline.

We're talking stubborn willpower here, and frankly it's a surprise that a dog this small can contain so much of it. In my experience with Hercules – one shared by countless dachshund owners – this is a hound that is capable of doing almost any canine task, but only when it decides the time is right. From going into a down position, playing fetch or performing tricks like shaking paws or rolling over, the sausage dog is largely deaf to instruction. I can position myself in front of Hercules and command him to 'Sit, sit, SIT!' and he'll simply blink back at me like I'm asking myself to do something but my body has forgotten the moves.

Even performing a task for a treat rarely washes with the sausage dog. Having trained Sesi, a German shepherd who loved to learn, I kept her skills sharpened with regular command workouts. Hercules would always be drawn to watch as I put Sesi through her paces, but only because he had registered that I tossed her a treat every now and then as a reward for her focus and commitment. Instead of attempting the same tricks, Hercules would simply regard me like he deserved a treat for successfully being a dachshund. Inevitably, I gave in to his persistence. In fact, I realise I have continued to reward him in the same way ever since. Through his uncompromising effort to get his own way as a sausage dog, I find I even praise him for that achievement.

## BE MORE SAUSAGE

**In seeking to become an effective persuader, always play the long game.** The dachshund doesn't expect instant results. It's just consistent in its view. In humans, this might come across as being difficult and uncompromising. The key is to maintain your position for hours, days, weeks or even years.

Ultimately, aim to normalise the position until eventually everyone considers their own opinion on the matter to be wrong. It takes immense patience and self-belief, but this power of persuasion is open to anyone. You might be the little guy in life, but if you can enter a battle of wills prepared to go the distance, then you'll emerge victorious.

## SIEGE MENTALITY

It's no surprise that a dog so used to ridicule might feel the need to protect its personal space. Your classic guard dog has no need to kick off inside the house at the slightest noise outside. The bull terrier or Dobermann can be confident that if it turns out to be actual burglars, and not a robin at the bird table, they'll creep in through the back door and then freeze on realising what a terrible mistake they've just made.

Without the same physical presence, the dachshund can't afford to be so relaxed. If the bad guy makes it over the threshold to find a sausage dog home alone, you can say goodbye to your valuables. For such a small breed, however, it's fitted with a deep, broad chest. This is what has allowed it to evolve a souped-up pair of lungs that can produce a bark like the sound of some prat exploding a crisp packet. It's an abrupt, forceful and startling sound. Without seeing the dog responsible, your intruder would be forgiven for thinking it's coming from everything

the sausage isn't. As a result, dachshunds are often considered to make better guard dogs than the real deal.

I'll be frank, Hercules can drive me up the wall with his belief that the world outside our four walls is a hostile place. Often, he will station himself on the back of my sofa so he can see through the window and stay there for hours on end.

'Have a day off,' I'll grumble when he launches into a rage at small children heading for the local primary school. 'Nobody is out to get you.'

My request always falls on deaf ears, of course. Through his eyes, keeping sentry like this has kept him safe in his own home for his entire life. For Hercules, standing down would be as unwise as choosing to stop breathing. It keeps him alive and kicking, so why stop now?

## BE MORE SAUSAGE

**When it comes to personal safety, the dachshund likes to be prepared for the worst at all times.** We don't need to go as far as planting ourselves at the window as the dog likes to do, braced for a home invasion. It's about adopting sensible, practical measures so that if societal law and order breaks down overnight, we're ready. Practically speaking, we just need to make sure that doors and windows are secure at all times, with a window sticker visible to anyone who approaches warning of the presence of a patrol dog inside that's anything other than our long and low-down little friend.

# 4. WEINER WARS

Nobody likes conflict. Handled badly, it can be frustrating, stressful or even brutal and bloody if allowed to spiral out of control. For the sausage dog, however, it's just another obstacle in its path. As everything in life is effectively in its way, this is one dog hard-wired to tackle disagreements head on. Not only that, it has refined a way to do so that guarantees a win without anyone feeling as if they're on the losing side.

## EMOTIONAL WARFARE

Sun Tzu, author of the fifth-century classic treatise on military strategy *The Art of War*, understood how to win fights without getting punched in the face. Essentially, it's all about planning, luring your opponent into thinking you're weak and then striking in an unexpected way. With these key principles in mind, it's fair to say the sausage dog has mastered the art of war.

Unlike other dogs, which simply steam in as a show of strength, we know the dachshund prefers not to get physical. Instead, keeping a safe distance, it wages an emotional campaign by acting like a crazed psychopath just waiting to be provoked. It's an effective method for the dachshund to get the measure of bigger breeds, which is pretty much all dogs, but it's not the only strategy up its short sleeve.

When it comes to winning arguments, the dachshund deploys brains over brawn and the power of feelings, not fists. Yes, it's a dog prone to angry outbursts, but this is effectively just a warning shot. If provoked, the sausage will call upon an emotional armoury in order to march into battle.

Here, all manner of impulses can come into play. From petulance to provocation (in the presence of someone who can quickly intervene), the sausage dog knows how to bait the enemy and then strike in a way that won't come back to bite him.

Hercules is a dog driven by emotions as much as treats. As a pup, he was too young for the big dog chew that Sesi enjoyed. Even so, he did his level best to claim it as his own. At first, he attempted to pull it from her jaws. My shepherd could be a patient dog at the best of times, but after endless assaults she yelled at him so furiously that he left a little puddle on the floor.

For several hours afterwards, Hercules kept his distance from Sesi. If she looked in his direction, the chew clamped protectively between her jaws, he would just whimper. He'd look so pathetic that poor Sesi clearly

felt bad and did her level best to ignore him. I couldn't help but notice that as soon as she turned her attention elsewhere, the sausage dog would miraculously cease cowering.

Finally, having moulded her feelings like putty in his paws, Hercules opened a second front. This time, his attempt to seize the chew in Sesi's possession was dressed up as play. It was the kind of ear swinging that was instantly annoying for poor Sesi, and yet what could she do? Nobody wants a puppy hanging from their lug hole, but because Hercules had pitched it as affectionate rough and tumble, my poor shepherd simply had to weather it. As love bombs go, it was an effective weapon, and one that saw a dog ten times the size of Hercules give up her favourite treat for the sake of some peace and quiet.

From then on, the chew belonged to the dachshund. As if to reinforce the transfer of ownership, Hercules took himself to Sesi's bed and worked on it from there.

I remember the shepherd turning to me in confusion, as if she wasn't sure what had just happened. It was, in my view, the conclusion to a conflict that the sausage dog had won without firing a single shot. It all came down to emotional might and manipulation from a hound that looked about as threatening as a foam hammer.

## BE MORE SAUSAGE

**There's no room for emotional manipulation in the human world, but like a true dachshund we can benefit from learning to understand others.** In dealing with any situation, it's easy to get caught up in our own thoughts and feelings. Whether we're faced with strangers, friends or enemies, focusing inwards risks failing to read a situation properly.

The sausage dog is switched on emotionally, not just to itself but to the world around it, and we, too, can find our place in it by doing the same thing. Working out what makes others tick is key here. The dachshund may forge connections to seek an advantage, which is fair enough when you're a foot long and inches off the ground, but when faced with someone eye to eye, you'll each benefit from taking time to look into both heart and soul.

# MANAGING CONFLICT

We all want to live in peace, without hassle, grief or fear of any kind, and the same goes for the dachshund. As a natural-born underdog, however, it's understandable that this seemingly soft target has developed strategies and solutions to protect itself during troubling times.

When it comes to escalating a minor episode into a major event, the dachshund is quick off the mark. That squirrel on the garden fence? You can't be too careful nowadays, which is why the sausage dog will react as if the place is about to come under attack from a mob of acorn hoarders.

Hercules only has to hear a scratch or scrabbling from outside to snap out of his deep sleep on my office sofa. In a heartbeat, he'll stop snoring and start barking so abruptly that if I've taken a slug of tea at the time, it'll end up on my screen. Through his eyes and ears, everything is a potential threat. There is no room to pause, assess or even stand down. In his view, isn't it better to assume the worst than do nothing and then suffer a home invasion by a gang of ultraviolent squirrels?

In my view, this is the downside of dachshund ownership. They are never off duty and always on guard, no matter how many times I have assured him that the local wildlife presents no threat. Yes, this canine call to arms can be testing, but is there any advantage in viewing every non-event as a major catastrophe in the making?

The dachshund would argue that assuming the worst at every turn, and kicking off accordingly, means going through life feeling only pleasant relief. It's an extreme way of looking at the world, but one with some grounding when you're constantly at risk of being accidentally stepped on.

## BE MORE SAUSAGE

**We may not exist in quite the same danger zone as the dachshund on the physical front, and yet there are always situations that can make us feel small or even threatened.** That walk home after hours? Running around in circles shouting loudly won't get us far, but we can signal that we're not worth messing with in more subtle ways. Phoning a friend and talking to them while walking can help you to feel less vulnerable, but if you want to bring out your inner dachshund, focus on discussing subjects like your mastery of martial arts or recent experiences as a mercenary. It's all about projection, which is the sausage path to peace of mind.

## PROTECT AND SURVIVE

With a sausage dog for company, your personal safety is guaranteed. At least, that's how the dachshund views its role in the relationship. Shielding its owner from every threat gives it a sense of purpose and duty.

Metaphorically, this is a dog that comes dressed in a suit, dark glasses and a discreet earpiece. It'll keep you under constant surveillance and react with lightning speed at the merest hint of danger. Most owners know the dachshund wouldn't actually take a bullet for them. For the sausage, however, the intention is enough.

Such vigilance on the move is totally unnecessary, of course. We have nothing to fear from old ladies at bus stops, while by and large cats aren't hell-bent on killing us. The sausage dog can never allow itself to be complacent, though, and positively thrives on its mission to make sure you live to see another day.

### BE MORE SAUSAGE

**Only bodyguards come close to providing the same vigilance as dachshunds, but we can still follow their example in spirit.** If we all just spent a little more time looking out for the people we cared about, this world would be a better place.

When it comes to watching over someone, the sausage dog thrives on a sense of duty, as can we all. There's no need to assume that person is incapable of looking after themselves, as dachshunds often do, but a willingness to assist when needed can go a long way to helping everyone make the most of life.

'As a natural-born underdog, it's understandable that this seemingly soft target has developed strategies and solutions to protect itself during troubling times.'

## THE VICTIM CARD

On a walk with Hercules, he's always on the lookout for other dogs. It's only natural for this territorial animal, and we just hope that along the way we'll meet nothing but the friendly type, the dopey or indifferent.

Should we come across a dog looking for trouble, Hercules will deploy the standard sausage approach of asserting itself from a distance. We know this can be an effective strategy, forcing the other dog to focus on the dachshund's ferocious spirit rather than its comical body. Sometimes, however, we meet a dog that is deaf to the noise and refuses to be intimidated. Hercules might yap so hard that his front paws lift off the ground, but if he suddenly finds himself under attack, he'll flee.

Moments later, before the aggressor has caught up with him, Hercules will give out a yelp as if he's just suffered a grievous bite to the bottom. The noise is so anguished and alarming that the chasing dog will usually stop dead in its tracks and appeal to its owner like a footballer who has been whistled by the ref for a foul he didn't commit.

All of a sudden, that poor dog is focused not on Hercules but what kind of unjust reprimand it's about to receive. As the owner rushes to apologise, Hercules slinks up behind my legs, possibly to hide the fact that he's suffered absolutely no injury whatsoever, and only comes alive once more as they leave, to ensure he has the final word.

## BE MORE SAUSAGE

**When faced with trouble, and you're all out of escape routes, don't be afraid to default to drama-queen mode.** The dachshund is a natural when it comes to distraction, deflection and division, which is effectively achieved by assuming the role of victim at an early opportunity. By feigning injury of any kind, from emotional to physical, it's only natural that people look to the perpetrator. Even if there isn't one, you've created a window of opportunity here.

Seize the advantage created by the confusion to extract yourself from danger, but don't push your luck. You don't want to be the sausage dog that cried wolf. Nor do you want to get anyone into serious trouble. It's about self-preservation, not punishing the innocent.

# 5. THE LOWDOWN ON FRIENDSHIP

There is one friend the dachshund can count on through life. This is someone it can call upon for company, fun, support and commiseration. As a result, the sausage dog never feels alone, which is important when the world essentially reacts to it as a living, breathing joke.

So, who is this faithful friend? It's the sausage dog itself.

People often mistake the dachshund for an aloof, self-absorbed breed. The kind of dog that walks into a room and looks right through you, then turns and switches off the light on its way out. This is unfair on the little guy. From a survival point of view, a big attitude is essential for the dog to seize attention and prevent it from being trodden on.

We're talking about self-confidence here, which isn't just required by the sausage dog to stop itself from being flattened. For anyone, this kind of inner assurance is as central to feeling at peace as it is to forging bonds with others, and the sausage dog knows which comes first.

In order to be a good friend to others, the dachshund understands that it needs to make friends with itself first. That doesn't mean it considers itself to be perfect. It's just focused on all the positive things it has to offer. Not only does that help the dog feel good about itself, it also ensures that others will pay attention to it for all the right reasons, and that's where friendships are forged.

From there, as trust builds between dog and human, or dog and dog, or even dog and cat, the dachshund can open up about its worries or insecurities, or be there as a source of support and positive energy. That's what good friends do for one another. It means that at any time, whether or not they're in company, the dachshund is never alone.

So, let's explore the social world of the sausage dog, from its foundations as a free agent to its reputation for putting every creature, great and small, at ease in its company. Ultimately, if it can work for the dachshund, surely it can work for us, too.

'From a survival point of view, a big attitude is essential for the dog to seize attention and stop it from being trodden on.'

## THE SOLO SAUSAGE

Whether it's among its own kind, or in a pack of different shapes and sizes, the dachshund is often at the centre of the action. Its larger-than-life personality ensures both attention and respect from its pooch peers. Even if other breeds are just totally bamboozled by the force of its presence, the sausage is quite content in the company of other dogs.

This is not a hound that surrounds itself within a pack to feel confident. It brings that in plentiful supply, which is down to one simple fact: the sausage dog is quite comfortable in its own company. Somewhere in evolutionary history, it took a long, hard look at itself and decided to stop being on such a downer. Blaming the world around it for its lot in life was just leaving it feeling miserable and insecure. Instead, it learned to like itself as a dog, and then recognise that it had lots to offer. Finally, the modern dachshund emerged as a hound that's best friends with itself as much as any breed prepared to look down and treat it as an equal.

## BE MORE SAUSAGE

**The dachshund can be a sociable dog but is equally content as a solo sausage.** It all comes down to inner confidence, which has evolved thanks to this being the most vulnerable of all breeds when it comes to attracting mockery. It's only natural to have insecurities about our physical appearance. In a constructive light, it helps us to be more self-aware. The problems only really kick in when we allow such doubts to build. Then, we can cease to live our lives freely because we're worried about what other people think of us.

The sausage dog stopped worrying about such things a long time ago. It figured out that life is just too short to fret about looks, and then set about celebrating all the aspects of its character that other dogs and people admire. It's feisty, funny, spirited and smart. Once we've had a good chuckle at the hound huffing towards us like a field marshal on four short legs, we find that these are the qualities that endure. We can do the same by focusing on a winning personal quality. It doesn't have to be much – our smile or our sense of humour – but it can be a buzz when we see how people react to it. Ultimately, it forms a foundation on which we can build the kind of confidence that helps us to be ourselves – whether we're enjoying time on our own or at the heart of a social scene.

## MAKING FRIENDS AND INFLUENCING EVERYONE

The dachshund finds itself in a world in which it must walk in the shadow of almost all other dogs. It would be easy to assume that the breed has evolved to be naturally subservient to its canine peers. Instead, the sausage dog has compensated to survive, thrive and even call the shots.

So, how does the dachshund relate to other dogs, make friends and influence them, and what can we learn from its success?

In meeting someone new, our first impressions can speak volumes. We're quick to form opinions early on, often based on appearances, which is all part of a subconscious threat assessment and our fight-or-flight instinct. It's a survival strategy, and the reason we don't rush to embrace angry drunks at parties.

While the sausage dog has learned to see beyond the body it was born with, it's well aware that others won't miss it. Yes, the dachshund could toddle across the local park in a low-key manner, but you can guarantee that every dog within a hundred-metre radius will make a beeline for it to sniff and scoff.

That's why the sausage dog makes every effort to take control of the situation before such a rush to judgement.

Rather than shy away from other dogs, it'll behave like it owns the park. Off the lead, the dachshund will not hesitate to approach strange mutts with purpose and confidence. It's the dog equivalent of donning a high-visibility vest. No matter what that individual looks like, even if you know that you could take them down in an arm wrestle, the first thing you register is the fact that they're in a position of authority.

The sausage dog doesn't default to aggression in this situation, but it is assertive. It wants to make a new friend, but first it has to signal that despite its physical stature there is a clear order of rank. The dachshund is bold here but feels no need to get right in the face of

the other dog. Instead, it banks on the fact that this four-legged friend-in-the-making is still trying to process what on earth is showing such interest here. Is this creature even canine or some weird 3D-printer prank? It's a brief glimmer of opportunity, but by showing an inner confidence alongside a genuine interest in the other dog, the dachshund quickly disarms the other party.

## BE MORE SAUSAGE

**It takes courage to break the ice with people.** Often, it's easier to submit to our anxieties and keep our distance. This is to deny ourselves the chance to make a new friend, and the dachshund never squanders such an opportunity. To overcome any sense of self-consciousness or awkwardness, go in with a good question. Show an interest in that individual, rather than getting caught up in how you're feeling, which frees you to focus on their response. It's flattering when someone pays you attention in this way, which is how every sausage dog can boast a wide social circle and respect from its peers.

## SECURITY IN NUMBERS

Nature dictates that small, vulnerable creatures can significantly increase their chances of survival by sticking together. From shoals of fish to flocks of starling, these little fellas effectively form gangs to see another day. While the dachshund is perfectly capable of operating solo and taking charge of social situations by force of will alone, this is also a dog that will team up with its own kind when necessary.

A collective sausage-dog walk is an ideal opportunity to observe these hounds together. It's a chance for individual dachshunds to recognise that they are not alone in this world. Recently, at one such event, I watched Hercules trot up to a wire-haired young lady pooch who looked like the Farrah Fawcett of sausage dogs. He sniffed her face respectfully and then made the long circle round to do the same thing with her bottom. There was none of the momentary tension I would expect when any other dog finds itself under inspection by a dachshund. Sharing the same physical appearance – and, by extension, a lifetime's experience of disadvantage – just seemed to bring them together straight away. With the greeting ritual complete, the couple duly joined forces to seek out new recruits to their cause.

Within a short space of time, once everyone had arrived, the walk commenced. Somehow, Hercules had positioned himself at the heart of the sausage army. All the dogs seemed quite content, as if they'd known each other for ages. Putting this bond of trust to the test, a golden retriever appeared through the bushes and did a long double-take. It can't be every day that a dog comes across more than one hundred miniature dachshunds with legs so small they appear to be moving on a grass travelator. Judging by the way the retriever bounded towards them, tongue flapping like a wind sock, the instinct to charge in and mess with them was irresistible. At once, the sausage dogs responded as if the retriever intended to crash an invitation-only event. Most striking

'Off the lead, the dachshund will not hesitate to approach strange mutts with purpose and confidence.'

of all was the din, as every single member of this pint-sized pack began to bark and yap while rounding on the interloper. At first, the retriever read it as a game. Surely these toy-like canines couldn't be serious? The retriever pulled up for a moment, head cocked as it processed the scene, and then turned tail in the face of a swarm.

Assembling in numbers does not make sausage dogs more aggressive. Yes, it emboldens them, but collectively they're simply out to be themselves. Off the leash, they will gambol and play well together. There is no social tension or pecking order to be established. All dachshunds are equal in their own eyes. It's just that they also consider themselves to be more equal than anything else around them, which can be formidable in a pack situation.

A social group of sausage dogs will happily do their own thing in the park, but should another dog attempt to dominate proceedings, they will respond. Even if this unwanted guest is being a pest, the pack won't start a fight. They'll just come together in order to be bigger than the sum of their parts and encourage the interloper to see sense. It's a rare moment for the little dachshund. All of a sudden, they are taken very seriously indeed. Despite this new-found strength, all they want to do with it is request the kind of respect we should all afford each other as individuals.

## BE MORE SAUSAGE

**We can all draw strength in numbers, but it's important to do so responsibly.** The sausage dog is no hooligan. It doesn't join forces in a tribe to cause trouble. When you're born into a life that seems to have conspired against you, finding yourself among like-minded souls who share your disadvantages can be empowering. If anything, it's a celebration.

Should anyone try to spoil your fun, remain united as a group. Don't be the one who kicks off, hoping that your mates will back you up; don't find yourself dragging back a friend and pleading with them to leave it because it isn't worth it. That kind of conflict can be avoided by standing together in the face of trouble. By acting as one in a show of solidarity, and respectfully establishing boundaries, you'll be free to enjoy yourself with friends.

## THE LOYALTY CLAUSE

When it comes to unconditional love, the dog leads by example. It's committed, protective and adoring at all times, and thoroughly deserving of a place in our homes and hearts. A dog's devotion is second to none, along with its ability to read our emotions and provide support and unswerving companionship.

Then there's the dachshund.

From experience, the sausage dog is perhaps the only breed that can show unconditional loyalty with just a tiny escape clause built into the deal. This doesn't make it any less capable of being a committed and dependable four-legged friend. If anything, its ability to withhold affection can serve as a wake-up call if we've allowed our own part of the bargain to slip.

There is a reason why we're wary of strangers. It's all part of our survival strategy and helps to protect us from meeting an untimely end or finding that our bank accounts have been drained by fraudsters. Trust is the building block for all friendships and relationships, and yet sometimes we can let our fears get the better of us. As a result, we miss out on the opportunity to let someone special into our lives.

Being close to the ground, often going below the radar for humans, the dachshund can be a dog that understandably keeps its distance. It's not being standoffish, which people often think. It just doesn't wish to be squashed. In reality, the sausage dog is like any other breed when it comes to forming bonds. As puppies, they're a bundle of fun, curiosity and mischief, and quickly connect with the individual responsible for their care. They enjoy company, proving to be loving and dependable companions.

Where dachshunds differ from other dogs is in their standing within that human–canine relationship. For the sausage dog is no pack animal in search of a leader. Nor is it content to settle for an equal partnership. There might be a significant difference in height, but the dachshund

'There might be a significant difference in height, but the dachshund outranks its owner in every other way.'

outranks its owner in every other way. With no weight to throw around, it calls the shots in a unique and clever manner.

Hercules certainly had me figured out within a short time. He'd barely been with us for a week before I was carrying him around the house. All he had to do was face the foot of the stairs and give me a pleading look. This sense of helplessness pushed all the right buttons in me. Why would I make such a low-slung pup attempt a dangerous ascent to his spot in front of the radiator on the landing when I could just carry him up?

Naturally, Hercules understood that this was merely a gateway on my journey to complete servitude. The next step involved being trained by him to scoop him up and take him into the garden for a pee. Naturally I tried to make him walk there, but all too often the yard was damp with rain or dew. Once again, I'd look down at a forlorn little pup in front of the open door and find myself consumed with pity. From that point on, Hercules simply had to reinforce my training through routine and reward. It became second nature for me to pick him up, pop him down in the grass and then carry him back to the house. Safely inside, Hercules would wag his tail in gratitude, and then look over his shoulder at me until I realised he needed to be carried to the armchair for a rest.

In short, my sausage dog came to trust me as a source of help, support and assistance, and somehow that felt like a natural dynamic between man and dachshund. I am part owner, part carer and part mug, and in return he has been my constant companion with a listening ear whenever I've just needed to talk. It doesn't mean he's actually listening, of course, but that's fine. It all boils down to companionship. Hercules might keep me within eyeshot at all times in case he wants something, but that low-level presence means I am never truly on my own.

# BE MORE SAUSAGE

**When it comes to forging enduring bonds, consider letting people into your lives with the same searing honesty as the dachshund.** This is a dog that doesn't pretend to be any other breed. It can't hide who it really is, and so it turns that to its advantage. How? By making it quite clear what you're letting yourself in for from the moment you meet.

Like the koala, the dachshund is one of those creatures that looks like it won't survive without your help, yet it knows how to overcome all obstacles. One means of doing so is by looking pathetic so you'll offer a helping hand. In return, the sausage dog appreciates the effort you make, and is on call to play to its strengths in your time of need. Should you drop any food while eating, it's available to clear up so you don't have to, and if a leaf dares to fall from the branch of a tree outside your window, the trusty dachshund will make sure it doesn't lay siege to your house.

In a world that can leave us feeling small and vulnerable, relationships are key. The sausage dog instinctively understands this, which is why it forms such a strong bond with its owner. It might not bring a wage into the household, or know how to cook a nice meal, but everything it offers is delivered with passion and commitment. That makes it indispensable and helps the dachshund to feel secure, and we can follow its example. There's no room for complacency or laziness in any relationship if it's to endure, but sometimes it's the little things that mean the most when delivered with the best intentions.

# 6. HOUNDS OF LOVE

The bond between humans and canines is believed to go back almost thirty thousand years. Granted, early man didn't roam the Earth with a sausage dog. Knowing how predators might react, his survival instinct just wouldn't have permitted it. Nevertheless, the relationship between the two species has evolved and endured.

Humans and dogs have always helped each other. We once looked to our four-legged friends to assist us in hunting and to provide protection for ourselves and our livestock. In return, the dog received both food and shelter. Slowly, a sense of companionship developed and deepened. While human society became more sophisticated, the dog left behind its wolverine origins and adapted to domestic life. Throw in our skill at breeding and selection, giving rise to canines with particular qualities, and we now find ourselves spoiled for choice.

Some people are drawn to large dogs. Others like small dogs. There are fierce dogs, placid dogs, smart dogs, fast dogs, noisy, energetic, playful or spirited dogs. Whatever shape, size or temperament, however, we consider all dogs to be our friends.

Some say that dogs often resemble their owners, not necessarily physically but in terms of temperament. You might see a runner in the park with a terrier or lurcher, and question which one is striving for the personal best.

In the same way, it's no surprise to see someone who likes an accessory with a chihuahua for company. These dogs fit with the lifestyle of the people who love them. They often embody their owner's personalities, and the dachshund is no different.

Back at the sausage-dog walk, having chased away the retriever, Hercules and his friends roamed the park like canine conquistadors. The event was as fun as it was chaotic. With countless sausage dogs present, along with their owners and family members, it wasn't so much a walk as a collective swarming. Along the way, as the dogs flocked in formations, I chatted to the people who clearly adored them. I met a newlywed couple who considered their short-haired little hound to be the matchmaker, a mum of four who treated her unruly dachshund like a fifth child and an old lady who talked to her sausage as if it understood every word but felt no need to reply. They came from completely different walks of life, and effectively had nothing in common but a love

for one breed of dog. Nevertheless, this single factor told me more about them collectively than any other aspect of their lives.

During the course of that walk, in the company of so many dachshunds and their owners, I realised that nobody laughed at their dogs. These hounds weren't mocked for displaying a character at odds with their appearance or treated as a joke in any way. Instead, everyone wholeheartedly bought into the fact that the breed refused to be held back. The sausage dog had learned to liberate its spirit, and their owners stood in admiration. That's what brought them together and marked them out as dachshund kinds of people. Yes, they laughed, but they did so in joy, not jest. I had no doubt that the dogs thrived on the respect shown to their world view, and that this formed the basis of a lifelong bond.

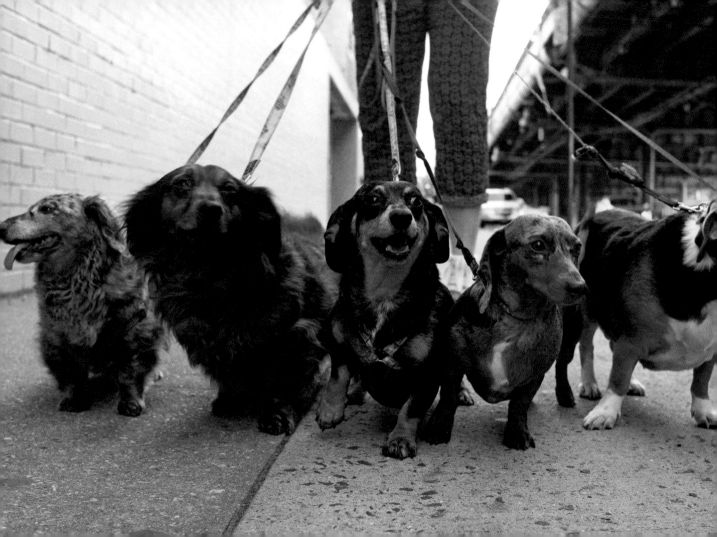

## SWIPE RIGHT FOR SAUSAGE

So, you've decided that you want a dog in your life. What's more, you've set your heart on a dachshund. Whether it's their shape, size or character, or a combination of all three, when you know that this is the breed for you then it's just a question of choosing one, right?

On three occasions in my life, I have taken on a dog as a puppy. When Sesi first skipped and tripped her way across the floor, I knew this little white German shepherd – disguised, at six weeks of age, as a seal pup – was the dog for me. Similarly, on finding myself faced with a litter of twelve spaniels, I selected the one who looked me in the eyes when I picked him up in the palm of one hand.

Then there was Hercules, who arrived in the house pre-selected by my wife and children. Even then, it wasn't a question of learning to bond with the sausage dog. From the moment he wobbled into my life, Hercules managed all the moves on his own terms. If I made any advances, from the offer of a lap to sit on or a treat held out between thumb and forefinger, he would respond as if he had been warned about people like me and then walk away.

I should stress that he wasn't the kind of social-savvy dog that was cancelling me here. Nor could I put it down to the sort of shyness you often see in puppies that need to establish trust before they'll come closer. Hercules did not lack confidence at an early age. That was quite clear from his character. He certainly had no issue when it came to getting to know my wife and children, which left me to consider where I might be going wrong.

The only difference, I realised, was in the way we viewed Hercules.

While Emma and the children welcomed him with open arms, I had yet to stop myself from double-takes and smirks whenever he appeared. Naturally, Hercules picked up on it right away. Understandably, he decided that I wasn't worth knowing until I'd had a long, hard think about my attitude.

Sure enough, once I'd become accustomed to having him around, Hercules made himself more approachable. He didn't throw himself at me. Dachshunds like to be in company at a distance, and that suited us both. Slowly, however, I found he was never far from my side. He's not clingy or suffocating as some dogs can be, but nor do I need to keep an eye on him when we're out and about in case he disappears. He's become just a constant, shoe-high presence. We are quite content to be around each other while living our own lives, which is the measure, I think, of true soul mates.

## BE MORE SAUSAGE

**To protect itself, without missing out on the opportunity of making great friends, the dachshund bides its time.** Through quiet observation, the dog creates an opportunity for someone to prove they're worth knowing, and not a total idiot beyond redemption.

This is an effective social strategy that doesn't just work for sausage dogs. When it comes to meeting new people, we all have to drop our guard a little – it's the only way to let them in – and yet nobody wants to get hurt. We might be hard-wired to make every effort with new acquaintances, but a little caution goes a long way. It cuts down on ill-fated Friend Requests on Facebook that you're obliged to accept while wishing you'd never rushed to introduce yourself. If only you'd spent the time checking their feed, seeing that they posted memes every five minutes, you could've avoided this whole sorry situation. By contrast, having deployed some quality control before it gets awkward, the dachshund has a genuine connection with everyone in its social network.

## MAINTAINING THE RELATIONSHIP

There are times when I need to leave the house without a wingman. I realise this is hard for any dog to process, and Hercules is no exception. As I zip up my coat beside the back door, he'll look up at me with a sense of looming dread. Naturally I feel bad, but then dachshunds aren't welcome at the dentist or the middle lane of the local swimming pool.

On my return, any other dog would practically perform backflips with excitement. I'd have no need to earn forgiveness for my absence. My presence is all that matters. It feels good, of course, to the extent that I'd never considered the sense of abandonment the poor dog went through as I endured a filling or botched yet another tumble turn.

Coming home to Hercules, however, I find he can barely bring himself to acknowledge me. I shake off my coat feeling like I've just been seeing another sausage dog and he knows it. An hour or so will pass before he comes around, and only if I spend some time with him. Then, once he's over that emotional hurdle, our daily routine resumes as if nothing untoward has happened.

As cold shoulders go, Hercules holds out just long enough to give me a shiver of remorse. He's not a clingy dog. Nor is he at all anxious. In fact, the dachshund is a breed that enjoys company without feeling the need to sit on your chest and pin you to the sofa, which suits me just fine. He enjoys company by sitting nearby but values his personal space as much as I do. Like all sausage dogs, however, he's not wildly happy if I take off without warning or breeze back in with higher matters on my mind.

Hercules never sets out to make me feel really bad. It's just a gentle reminder that there are two of us in this relationship. We each rate our independence, but equally we need to feel valued when we're together.

Of course, I could argue that briefing any dog about my plans for the day or sitting down afterwards to fill them in on the highlights is likely to be a waste of

breath. Until Hercules learns to read a note left pinned to the fridge or sits down over a cup of tea and even just pretends to be interested, I'm always going to come home to a less-than-impressed dachshund. Even so, in that short window when he's in a mood with me, I remind myself that I could do better. Not just with my sausage dog, but with the people in my life, too.

Space has a place in any relationship. When you're one half of a couple, it's important to maintain a sense of your own identity. In some ways, it's the oxygen that allows two people to thrive when they're together. Whether we've taken time out of the house, are feeling stressed at work or relaxed at play, coming home to good company is something we should value. As a breed that tends to be at home on sentry duty, the sausage dog knows that if we take this time together for granted, it can lead to us living increasingly separate lives.

## BE MORE SAUSAGE

**When I walk through the door and then head for my desk or the kitchen to get the supper on, Hercules is quick to let me know that I need to rethink my priorities.** A little tummy tickling will usually bring him round, while also reminding me that I should seek out my wife and metaphorically apply the same attention to her.

Unlike other dogs, the dachshund is not one for wholesale adoration of its owner. I have to work at bringing out the best in him, and that's just as it should be. In a sense, my sausage dog is there to remind me that relationships don't have to be high maintenance in order to be rewarding and enriching, but nor should they be taken for granted. With a little work from human and sausage dog, that conditional love will endure.

## SHARING THE BED

As every sausage-dog owner knows, the bed is not out of bounds. The dachshund may be defeated by many things that are too high to reach, like cake on a table or the top rack of a full, dirty dishwasher. However, the draw of the duvet is one ascent it will go all out to conquer.

For a dog that looks at me pleadingly from the foot of the sofa, silently requesting assistance, Hercules has no issue when it comes to the bed. He'll take a long run-up to gain some elevation, then scramble on board. Any bed in the house, regardless of whether anyone is sleeping in it, he'll go about making his own. This involves that circling activity that all dogs do before they settle. Given his length, however, this can be disruptive for any occupants. In my experience, Hercules will remain oblivious to my muttering and cursing while he makes himself comfortable.

'What's wrong with your basket?' I'll grumble, only to be met with a look that might well be an invite for me to curl up there and find out for myself.

To be fair, once he's bedded in, I am barely aware of his presence. Hercules tends to be a parallel sleeper, rather than a dog that drapes itself across me and threatens to smother me in my sleep. He knows not to thrash around, either. Instead, my dachshund finds a way to fall into channels created by legs or torsos, and then snuggles in, hoping that the body-warmth trade-off will justify his presence.

### BE MORE SAUSAGE

**There is no room for selfishness in the bedroom.**
Nobody wants to share with someone who constantly wriggles or turns with limbs flailing. The dachshund understands this more than any other breed. Given its body length, the dog is a master of spooning, which is all that we can ask of a partner when it comes to providing comfort and security in sleep.

# THE LONG AND SHORT OF LOVE

Make no mistake, the dachshund understands love like any other dog. It's one of the binding qualities between human and canine. We share a capacity for affection, and over time a lasting bond can build.

Loyalty is one of the central tenets of the dog's concept of love. There is something about that unquestioning canine commitment that we admire and even consider an example worth following. Wherever we roam, regardless of fate or fortune, our four-legged friend will remain at our side.

Unless, of course, we're talking about the sausage dog and you're about to head outside on a really cold, wet and miserable day.

Then, you might well find that it hovers at the threshold with a look of disbelief. You can make all the encouraging signals you want. It might warm you up, but that's it. The dachshund is effectively waiting for you to get the message and push on alone with whatever madness possessed you to leave the comfort of a centrally heated space.

It would be easy to single out the sausage dog for applying strict conditions to its capacity for love, especially when it comes to comfort. Through the dachshund's eyes, however, it's all about putting both your best interests first. In a way, it aims to provide the same checks and balances to your day that it applies to itself. Do you really think that downpour is going to hold off in time for you to walk to the shops, for example? What if you're wrong and it breaks? In some ways, this is a breed that has your best interests at heart more than any other dog.

So, next time you're faced with a dachshund seemingly stuck behind a forcefield across the front door, consider it an act of love and not defiance. It might be frustrating when the sausage dog refuses to comply. Then again, it's because it cares for you so very deeply that it's prepared to sacrifice a leg stretch in the rain and sit beside you on the sofa instead.

## BE MORE SAUSAGE

**Love presents itself in many shapes and forms.** For the dachshund, it's all about looking out for you in ways that benefit you both. The sausage dog is on hand to remind you of this at all times. It's an admirable quality, and one that translates very well to human relationships.

Some say true love is about making compromises or even sacrifices for the sake of your soul mate. Being more sausage means drawing a line across such extreme behaviour, especially if the weather is dismal. Declining the invitation to go out when you're not in the mood doesn't mean you love your partner any less. If anything, making alternative plans to do something indoors that you both enjoy could bring you closer together.

## EVERYONE'S A WEINER

Hopefully you picked up this book out of sheer curiosity and now you're seeing the sausage dog as an example to us all. For this is a hound that has worked out how to make the most of life, despite having the odds stacked against it. In any situation, it understands what must be done to transform its fortunes as underdog and guarantee the win.

Yes, it's an odd choice from which to draw guidance and inspiration. Ankle-high to us at best, the dachshund has literally been overlooked since it came into existence. And when we did peer down at a dog so long it quite possibly woke up in sections, our reaction was to laugh.

Today, we talk about resilience as an essential life quality. If we want to pursue our dreams and make our mark, we need to toughen up. The sausage dog might look like proof that Mother Nature has a sense of humour, but it won't be held back by its size, or others' reactions when it trots into a room. If anything, in terms of inner resolve, the dachshund makes all other breeds look like lightweights.

On paper, this is a canine that should crumble at the slightest challenge. In reality, the sausage dog stops at nothing to live life to the full. Sure, it can seem headstrong at times, and represents the kind of individual that would bag a deckchair with a towel at sunrise. For many of us, that kind of behaviour goes against social conventions. Then again, it's hard to stew when that person also buys all the drinks at the bar in the evening and proves to be the life and soul of the party.

Of course, we are not actual dachshunds, and there are some behaviours we can only adopt in spirit, if not in practical terms. Ultimately, being more sausage is about breaking free from the restraints we impose upon ourselves. We can do so with love and mutual respect for others, while refusing to conform to expectations. From overcoming insecurities about our physical and emotional shortcomings to chewing up social conventions that conspire to hold us back, this is our chance to unleash that inner dachshund, live long and prosper.

## ACKNOWLEDGEMENTS

I should like to thank my editor, Lydia Good, for not laughing me out of the room when I first suggested this book. As a way of examining life and revealing aspects we would otherwise overlook, I am aware that it sounds ridiculous. Then again, with a sausage dog at my side for the last decade - admittedly at ankle height - I have learned to rise above ridicule.

I should also like to thank the entire team at HarperCollins for their creativity, enthusiasm and good humour, my publishing wife, Philippa Milnes-Smith, and everyone at The Soho Agency, and my actual wife, Emma, who thought a dachshund would be a good idea all those years ago.

Finally, there's Hercules, for keeping me company through thick and thin, winding me up, keeping me grounded and ultimately opening my eyes.

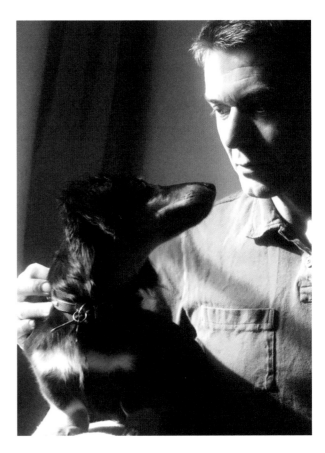